MASTER DRAWINGS

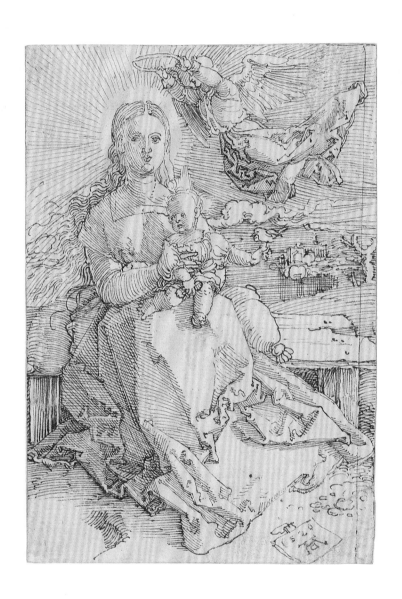

MASTER DRAWINGS

from the collection of the National Gallery of Victoria

Sonia Dean

The Robert Raynor Publications
in Prints and Drawings
Number One

The Robert Raynor Publications in Prints and Drawings
Number One

Published by the National Gallery of Victoria
180 St Kilda Road, Melbourne 3004, 1986

National Library of Australia Cataloguing-in-Publication entry
National Gallery of Victoria.
 Master drawings from the collection of the
 National Gallery of Victoria.
 ISBN 0 7241 0116 0.
 ISBN 0 7241 0115 2 (pbk.).
 1. National Gallery of Victoria – Catalogs.
 2. Drawing – Catalogs. I. Dean, Sonia, 1937- . II.
 Title. (Series: Robert Raynor publications in prints
 and drawings; no. 1).
741.9'074'099451

Editor: Judith Ryan
Design: Kathy Richards and Bill Reid
Photography: Sue McNab
Typesetting: All Graphic Industries
Printing: SouthBank Printing Services

Cover illustration
Andrea del Sarto Italian 1486-1530
Study for St John the Baptist
Red chalk
38.5 x 19.5 cm
National Gallery of Victoria
Felton Bequest 1936

Frontispiece
Albrecht Dürer German 1471-1528
The Virgin Crowned by an Angel
Pen and ink
Inscribed l.r.: AD in a monogram and dated 1520
13.7 x 9.5 cm
National Gallery of Victoria
Felton Bequest 1936

ACKNOWLEDGEMENTS

I should like to thank a number of people for their help with this project, in particular Irena Zdanowicz for reading the manuscript and for some useful suggestions, Judith Ryan for her unstinting work in editing and for so carefully seeing it through to publication and Daphne Hewlett, who not only typed the manuscript, but has been helpful at each stage of its preparation.

Sonia Dean

EDITOR'S NOTE

As repeated reference is made to two exhibitions, these are cited in abbreviated form. 'The Art of Drawing: 100 Drawings from the Print Room of the National Gallery of Victoria and some other Collections', National Gallery of Victoria, Melbourne, 3 December 1964-February 1965, appears as 'The Art of Drawing', 1964-65. 'European Master Drawings and Australian Watercolours from Three Australian Collections 16th-20th Century', Hermitage Museum, Leningrad, A.S. Pushkin Museum of Fine Arts, Moscow and the Museum of Western Art, Kiev, 15 December 1978-31 March 1979, appears as Hermitage, Leningrad, 1978-79. The catalogues for these two exhibitions are cited in the Literature as: U. Hoff, *The Art of Drawing,* 1964, and S. Dean, Leningrad, 1978. Other publications abbreviated in the Literature are: Ursula Hoff & Margaret Plant, *National Gallery of Victoria: Painting Drawing Sculpture,* F.W. Cheshire, Melbourne, 1968, cited as U. Hoff & M. Plant, *Painting Drawing Sculpture,* 1968; and Ursula Hoff, *The National Gallery of Victoria,* Thames & Hudson, London, 1973, cited as U. Hoff, *The National Gallery of Victoria,* 1973.

Judith Ryan

THE ROBERT RAYNOR
PUBLICATIONS IN PRINTS AND DRAWINGS

Mr Robert Raynor is one of the Gallery's most generous donors. His name will forever be associated with the Robert Raynor gallery which is used for the exhibition of works on paper. Now Mr Raynor has generously agreed to endow through The Art Foundation of Victoria a series of special publications, to be known as the Robert Raynor Publications in Prints and Drawings.

It is indeed appropriate that the first in this series highlights master drawings – one of the most precious parts of the Gallery's entire collection. Furthermore, the extreme sensitivity of drawings to light prevents them from being exposed to the general public for extended periods. Yet they are central to an understanding of the tradition of Western art for in drawing, the role of observation, of putting down immediately observed experience is encountered most directly.

The collection of European, English, Australian and American Prints and Drawings in the National Gallery of Victoria is the richest and most comprehensive in the southern hemisphere. The printroom is an indispensable student resource, open to scholars and artists alike for research. The inception of the Robert Raynor Publications in Prints and Drawings enables the Gallery to make its great holdings in the graphic arts known to a wider audience than ever before.

Patrick McCaughey
Director

A HISTORY OF THE DRAWING COLLECTION

In its first years from the 1860s the Gallery's collecting policy was confined largely to the acquisition of plaster casts and copies of old masters in an earnest intention to educate and enlighten the public of this new colony. The first drawings began to make their way into the inventories only after thirty years of collecting, and their acquisition was spasmodic even then. The drawing collection thus got off to a slow start and, having no core private collection on which to build, did not emerge as a distinct entity until well into the 20th century.

The boom period of the 1880s in Victoria was followed by the severe depression of the 90s and funds for art acquisition were few. Bernard Hall, appointed Director in 1891, a position he was to hold for the next forty years, had strong views on the value of drawing and prevailed on the Trustees in 1892 to allow £100 for their purchase, appointing Joseph Pennell, the American etcher, friend and biographer of Whistler, to act as London buyer. Approval was given in 1894 and again in 1897 for a further £100 to be spent on what was referred to as 'black and white'.

It seems that among the first drawings to enter the collection was a work by du Maurier in 1892, but first to appear in the inventories were: a study of a head by Menzel, bought from the artist's studio, some sketches by Lord Leighton, a work by Pennell himself and a drawing by Dicksee, whose popular painting *The Crisis* had recently been acquired for the Gallery by Herkomer. The latter drawing had only a brief stay in the collection, for the stockbook records that it was exchanged in 1905 for 'an anatomical study of Hercules' proving that the plaster cast still held sway. The first substantial European drawing to enter the collection was Burne-Jones's *Ladies and Death*, bought from the Boyce sale at Christie's in 1898. Clearly Pennell's acquisitions met with general approval, for in a report dated 1900 Bernard Hall wrote: 'Mr Pennell, I consider, has done splendidly', making at the same time some less flattering remarks about other advisers.

In 1904, a bequest which was to change the face of the Gallery and the nature of its collection was left by a local merchant, Alfred Felton (1831-1904). His substantial bequest, although divided between hospitals, charities and the Gallery, transformed the purchasing power of the Gallery overnight, enabling it now to look seriously to international markets.

It was decided that a London Adviser should be appointed and Hall was sent in search of a suitable candidate; at the same time he was allowed the sum of £4000 to spend on Felton acquisitions. His major purchase was a painting by Pissarro, but he did buy some drawings. In England he acquired the massive chalk drawing by Ford Madox Brown, a cartoon for the mural of *The Baptism of Edwin* in the Manchester Town Hall, while from Agnews he bought four Charles Keene drawings and a Sandys, but in Europe only some disappointingly minor examples. The Adviser he recommended was the English painter, George Clausen, but Hall still loyal to Pennell, whose tastes seem to have coincided with his own, suggested him as one of the two additional advisers.

In the first years of Felton buying, acquisitions were nearly all works by English contemporaries or the recently dead: Ruskin, Leighton, Shannon, Swan and Legros, who had become a British citizen and had been Professor at the Slade. In addition, a group of studies by Burne-Jones for *The Golden Stairs, Briar Rose* and two cartoons for stained-glass windows now joined his drawing, *Ladies and Death* in the collection.

In 1907, further Pre-Raphaelite works followed with five drawings by Holman Hunt, including the head of a youth for *The Hireling Shepherd* and a study for *Claudio and Isabella*. The younger generation of English artists were also represented by Muirhead Bone and Brangwyn. For the next few years the European drawing collection again seems to have come to a stand-still but the end of the first world war, and the appointment of a new Felton Adviser in 1918, changed all that. Until now, the small drawing collection had numbered only a handful of interesting works, but the next acquisition was to be quite remarkable by any standards. Robert Ross, the writer, and executor of Oscar Wilde, proposed the

purchase of a group of Blake watercolour drawings for Dante's *Divine Comedy* from the forthcoming Linnell sale in March 1918. Through careful pre-arrangements with the Tate Gallery, Ross was able to acquire thirty-six of the 102 drawings for the Melbourne collection. Ross's sudden death a few months later and unforeseen delays in packing the drawings held up their arrival in Melbourne until 1920. Sadly, this, now one of the glories of the collection, was greeted by the press on its arrival with incomprehension and derision. A hostile *Argus* reported: 'no justification can surely be shown for the purchase of so many artistically inferior pictures, which will no doubt before long find their way to the cellars.'

Collecting had until now a strongly English flavour, but in the same year, 1920, the first major European drawing came into the collection; it was the exquisite Ingres, *Lady Jane Montagu*, made in Rome in 1816, and this was followed in the next years by other great French drawings, two by Daumier and one by Millet.

In 1923, the first private collection of drawings was acquired by the National Gallery of Victoria. It had been put together in Tasmania by Robert Sticht, 1856-1922, an American metallurgist who, in 1894, had gone to Tasmania as chief metallurgist at Mount Lyell Mining and Railway Co. He was interested in art, music and literature and was an inveterate collector of all manner of objects. His drawing collection included a wide range of Italian drawings, some of the English school and, though uneven in quality, did contain outstanding examples like the Canaletto *Capriccio,* the Rosa sketch of Empedocles and Franco's *Virgin and Child with Magus.*

After this burst of activity, European drawing acquisition again tailed off for the next few years when mostly Australian works were acquired. The next high point, perhaps the most important in the history of the European drawing collection was 1936, the year of the Oppenheimer sale. Henry Oppenheimer's collection of old master drawings was renowned for its quality, including as it did many remarkable works gathered on the dispersal of other distinguished collections like Heseltine's in 1912. The Oppenheimer sale was held at Christie's in July 1936, and Randall Davies, bidding for the Felton Bequest, secured a group of works which were to form the core of the Melbourne old master drawing collection with examples by del Sarto, Rembrandt, Parmigianino, Dürer, Arent de Gelder, Boucher, Lievens, Dusart and van Dyck.

A second private collection was acquired in 1939 in the form of the Howard Spensley Bequest. Howard Spensley, who had been born in Melbourne but lived in England, left his collection of paintings, sculpture, bronzes, silver and drawings to the National Art Collection Fund, which handed it to his home state of Victoria. Among his drawings is the cartoon fragment for *The Holy Family of Francis I* by Giulio Romano, *A Naked Warrior* by Carracci as well as a Barocci and a Faccini.

During the war years 1939-45, after the Spensley Bequest, few European drawings found their way into the collection, but towards the end of the 40s there was a new impetus in collecting. Dr Ursula Hoff had been appointed to the department of Prints and Drawings in 1943, and her influence on the direction and quality of the collection was to be keenly felt for more than thirty years, first as a member of the Gallery staff and later as Felton Adviser. Thus, in the immediate post-war years, a group of Italian drawings including Zuccaro, Palma Giovane, Giovanni Battista Tiepolo, Amiconi, Piranesi and northern drawings by Jordaens and Metsu had all been purchased, and on a visit to London, acting as joint Felton Adviser with Sir Kenneth Clark, she was able to acquire the splendid Liotard *Woman in Turkish Costume,* and Gainsborough's Gaspardesque *Mountain Landscape.*

Sir Lionel Lindsay, himself a distinguished draughtsman and etcher, had made an extensive collection of drawings by Charles Keene, whose works had been so influential not only on European contemporaries like Degas but on the development of the black and white tradition in Australia. Sir Lionel's extensive Keene collection of 506 drawings, books and a lock of hair were purchased by the Felton Bequest in 1951. More drawings came in from his estate ten years later, which also provided the fine Giovanni Battista Tiepolo *Baptism.*

One bequest which actually excluded drawings was the Everard Studley Miller Bequest

of 1959 'for portraits of people of merit in history born before 1800'; and this innumerated painting, sculpture and engraving. The omission of drawing seems to have been an oversight, which could not be remedied, however, the pastel of Mme de Pompadour was acquired under the category of oil painting with which pastel is usually listed. Fortunately, the debate on its acquisition seems to have centred upon whether or not Pompadour was a person of merit rather than the medium of the work.

In 1972 another great collection was dispersed in the sale rooms – that of Lord Ellesmere, whose ancestor had acquired part of the noted Italian drawing collection of Sir Thomas Lawrence. The sale was set at Sotheby's for July 1972, and it was clear that here was a rare opportunity for Melbourne to add at least one significant old master drawing to its collection. As Gallery funds were insufficient, the State Government agreed to make a special grant to enable purchase. Prices promised to be high, so a brave decision was taken to retain the entire sum to bid for one major drawing, Annibale Carracci's *Ignudo* for the Farnese ceiling, but since the drawing was lot 66 and came towards the end of the sale, it left few options if the bid were unsuccessful. Happily, the gamble succeeded and the *Ignudo*, Guercino's *Hercules slaying the Hydra* and a small Carracci landscape were acquired. At the second Ellesmere sale in December of the same year, the Felton Bequest purchased the Barocci *Annunciation*. In the last ten years, the Felton Bequest has continued its tradition of great drawing acquisitions with the poetic Claude *Wooded Landscape* from the Wildenstein Album.

The successful launching of The Art Foundation of Victoria in December 1976 provided another major source of funds which has in turn reflected favourably on the drawing collection with such acquisitions as the first Pissarro drawing to come into the collection, a study for *The Poultry Market at Gisors,* acquired through Mr and Mrs William Jamieson, Members. In addition the continued support of the National Gallery Women's Association enabled the Gallery to acquire its first Bonnard drawing, while private gifts and donations and conditional gifts like the Picasso *Le déjeuner sur l'herbe,* have helped build the collection to its present strength.

The drawing collection, from its inception about 1892 until about 1920, had a distinctly English flavour, representing some of the pillars of late 19th century English art and some of its minor scions, but few Europeans. It is easy to regret with hindsight the drawings which might have been acquired at the turn of the century, yet the Melbourne acquisitions are probably typical of the collecting policy of a major English provincial gallery in the same period, and reflect the same tastes and ambitions. The Blake acquisition was inspired, and the Ingres and Daumiers bought during the same period are superlative examples. The Sticht drawings, though uneven in quality, gave a much broader base to the collection; but undoubtedly the first conscious attempt to assemble a group of major old master drawings was the Oppenheimer purchase. Subsequent judicious buying has reinforced the collection's strength in Italian old master drawings, and the smaller but fine group of French drawings and has augmented the more comprehensive collection of English works. Thus after less than a century of collecting, the National Gallery of Victoria holds some major examples of English and European drawing and can claim a collection of surprising richness and variety.

Sonia Dean
Principal Curator

LIST OF ARTISTS

BIOGRAPHIES OF ARTISTS

FEDERICO BAROCCI
Italian c.1535-1612, painter and draughtsman

The year of Barocci's birth is uncertain and is given variously as 1528 and 1535, but it is
known that he was born in Urbino and came from a prominent family there. He spent most
of his life in that city, although in the 1550s and 1560s he had commissions in Rome, later
travelling to Perugia, Arezzo and Florence. His last years were spent in Urbino under
the patronage of the Duke, Francesco Maria II della Rovere who commissioned *The
Annunciation*. Barocci was a pupil of Battista Franco, but much stronger influences were
Raphael, whose work he had studied in Rome, Correggio, Titian and the Venetians.

WILLIAM BLAKE
English 1757-1827, poet, mystic, painter, engraver and draughtsman

William Blake was born in London in 1757. He showed an early aptitude for drawing and
was sent to Henry Pars's school at the age of ten. In 1771 he was apprenticed to the
engraver James Basire who set him making drawings of the tombs in Westminster Abbey,
where he acquired his taste for gothic forms. Later he became a student at the school of the
Royal Academy, but was at odds with current views. His first and most celebrated book,
Songs of Innocence was completed in 1789 and hand-printed according to a technique he
invented. In 1794 he met Thomas Butts who became his first patron. In 1800 he left
London for Felpham to work on a commission for Hayley but returned to London in 1803
to work on his poetry and painting and on engraving designs for Blair's *Grave*. In 1809 he
held an exhibition of his works in London but it had a disappointingly small audience. In
1817 he met the artist John Linnell – a major supporter and benefactor. Finally from 1824,
he worked on the illustrations for Dante's *Divine Comedy* which were left uncompleted at
the time of his death.

FRANÇOIS BOUCHER
French 1703-70, painter, draughtsman and decorator

The son of an embroidery designer, Boucher was born in 1703 in Paris where he died in
1770. He studied briefly with Lemoyne then went to Rome with Carle van Loo. Returning
to Paris in 1731 he was admitted to the Academy two years later. Through the influence of
Madame de Pompadour and her brother, the Marquis de Maringy, he was employed at
Versailles, Marly and Bellevue, and was made Director of the Gobelin Tapestry factory in
1755. Through van Loo he was appointed Premier Peintre du Roi in 1763 and became
Director of the Academy in 1765. He worked indefatigably in all areas of the arts and was
an outstanding decorator, but under the critical attacks of Diderot and with changing tastes,
his reputation fell into decline towards the end of his life.

SIR EDWARD BURNE-JONES
English 1833-98, painter and draughtsman

Burne-Jones was born in Birmingham in 1833 and was educated at Oxford where he met William Morris who was to be an influential life-long friend. In 1854 he saw Pre-Raphaelite paintings for the first time and was deeply impressed. In 1855 he decided to become a painter. He met Ruskin early the following year and left Oxford for London where he had informal lessons with Rossetti. In 1861 he became a founder member of Morris Marshall Faulkner and Co., making tapestry and stained-glass designs for them. His first exhibition at the Grosvenor Galleries in 1877 was a sensational success. His early work had been drawn mainly from mythological and medieval subjects, but after visiting Italy the influence of 15th century Italian painting was evident. In the 1890s he exhibited several times in Paris. He was offered a baronetcy in 1894 and died in London four years later.

GIOVANNI ANTONIO CANAL, CANALETTO
Italian 1697-1768, painter, draughtsman and etcher

Antonio Canal, better known as Canaletto, was born in 1697 in Venice where he died in 1768. He was the son of a scene designer and this background and the works of the Venetian topographical painter Carlvaris must have influenced his early career. From 1719-20 he was in Rome where he made drawings from nature and saw the works of Roman topographical artists. On his return to Venice he continued to refine his own methods of recording topographical views which, combined with a new high-key palette, reveal the beginning of his own highly identifiable style. His paintings were particularly popular with English patrons and he spent from 1746 to 1755 in England where he received numerous commissions; however, he is most famous for his views of Venice.

ANNIBALE CARRACCI
Italian 1560-1609, painter and draughtsman

Annibale was born in Bologna in 1560, died in Rome in 1609 and was the most outstanding of the three Carraccis, the others being his brother Agostino and his older cousin Lodovico. In Bologna they founded the Accademia degli Incamminati which preached the direct study of nature and was totally opposed to the precepts of mannerism. He travelled to Venice and Padua where the influence of masters like Titian, Correggio and Bassano was particularly powerful, while later in Rome he was inspired by Michelangelo, Raphael and antiquity. In the 1590s he decorated the Palazzo Magnani but his greatest and most enduring masterpiece is in the Palazzo Farnese, Rome.

GIOVANNI BENEDETTO CASTIGLIONE
Italian c.1610-c.65, painter, etcher and draughtsman

Castiglione was born in Genoa about 1610 and died in Mantua about 1665. His work was influenced by Strozzi, van Dyck and Rubens, all of whom worked for a period in Genoa. A highly eclectic artist, he went to Rome in 1632 where he came into contact with the circle of Poussin, with Bernini and also studied Rembrandt's etchings. He travelled widely throughout Italy, living in Rome, Bologna and Venice, but from 1637 until his death, he lived mostly in Mantua, where he was in the service of Duke Carlo II.

CLAUDE GELLEE, CLAUDE LORRAIN
French 1600-82, painter, draughtsman and etcher

Claude was born at Chamagne in Lorraine in 1600 and is said to have trained first as a pastrycook. By 1613 he was working as a *garzone* for Cavaliere d'Arpino and Tassi in Rome. From 1618 to about 1620 he was in Naples but returned to Rome as Tassi's assistant. He was back in his native Lorraine for two years but finally settled in Rome in 1627 and, except for local journeys remained there for the rest of his life. The influence of Tassi brought him into contact with the late mannerists especially those of the northern school, like Bril and Elsheimer. From the 1630s his poetic landscapes enjoyed growing success and in 1639 he painted two works for Urban VIII. His reputation was firmly established by the 1640s and innumerable commissions came his way. The narrative landscapes of his early years gave way successively to a more heroic manner by the 1650s, and finally to a serene classicism.

HONORE DAUMIER
French 1808-79, painter, lithographer, draughtsman and sculptor

He was born in Marseilles in 1808 but the family moved to Paris in 1815 and Daumier remained there or in its environs for the rest of his life. In the 1830s he learned lithography and began to work for the anti-government newspaper, *Caricature*, as a cartoonist. He was imprisoned for six months in 1832 for a caricature of Louis-Philippe. This was also the period of his most notable lithographs, *Le Ventre Législatif* and *La rue Transnonain*. The suppression of political satire caused him to turn to social satire and he began to work for *Chiavari*, for whom he is said to have made four thousand lithographs. His real ambition was to paint, but his paintings were hardly seen until an exhibition at Durand-Ruel in the last year of his life, which though financially a failure was a success with critics. He was a close friend of Baudelaire, who collected his work, and the painters Delacroix, Corot, Cézanne and van Gogh. In the 1870s his eyesight began to fail and he spent his last years at Valmondoise in a house given to him by Corot, where he died in poverty.

HILAIRE-GERMAIN-EDGAR DEGAS
French 1834-1917, painter, draughtsman, printmaker and sculptor

Edgar Degas was born in Paris in 1834. Abandoning law, he entered the Ecole des Beaux-Arts in 1855, where he studied with a pupil of Ingres's, Lamothe, an ardent neo-classicist. In 1856, he visited Italy and remained in Rome for three years where he copied works of the 15th and 16th century Italian painters. In 1861, he returned to Paris where he met Manet and through him a circle of impressionists. He gave up history painting for contemporary subjects: the race course, the café and the theatre and exhibited in seven or eight of the impressionist exhibitions. As well as painting in oils, he worked in pastel and increasingly from 1880, in monotype, etching and wax sculpture.

EUGENE DELACROIX
French 1798-1863, painter and draughtsman

Delacroix was born in 1798 in Paris where he died in 1863. Like Géricault, he studied with Guérin and made copies after old masters in the Louvre, admiring in particular the works of the Venetians and Rubens. The paintings of Géricault and the English artists Bonington and Constable provided further influences. He first exhibited at the Salon of 1822 where he gained favourable critical notice, and by the 1827 Salon was established as leader of the Romantic movement. He was a supreme colourist and his subject matter is drawn from a wide range of sources which included literature – Byron, Shakespeare and Goethe, oriental imagery after his visit to North Africa in 1832 and the Bible. He was a central figure in the artistic and literary life of Paris, a milieu he documents in the *Journal* which he kept from 1823 to 1854.

ALBRECHT DURER
German 1471-1528, painter, engraver, woodcut designer and draughtsman

Dürer was born in Nuremberg in 1471, the son of a goldsmith and the godson of Anton Kolberger, the publisher. He studied first with his father and then with Michael Wolgemuth. After completing his apprenticeship he set out in 1490 to travel to Colmar, Basel and Strasbourg. In 1494, he went to Venice and on his return to Nuremberg, opened his own workshop. Active as a painter and printmaker, he revolutionized both engraving and the woodcut. In Nuremberg he knew leading intellectuals through his friendship with Pirckheimer, who encouraged an interest in the new humanism. Dürer returned to Venice in 1505-06. Commissions for paintings began to come from outside his native city and his prints had a wide distribution throughout Italy as well as in northern Europe. His chief patron from 1512-19 was Emperor Maximilian. In 1520-21 Dürer visited the Netherlands where he met Erasmus and was able to see works by Flemish masters. From 1515 until his death in 1528 he worked on a number of theoretical treatises: *The Art of Measurement, Fortification* and *The Principles of Proportion*.

PIETRO FACCINI
Italian c.1562-1602, painter, draughtsman and engraver

Faccini was born about 1562 in Bologna where he spent most of his life. His career was relatively short for his biographer Malvasia tells us that he first practised art when already an adult, and that he died in 1602 aged about forty. He studied at the Carracci Academy in Bologna, but is said to have quarrelled with Annibale and left, setting up a studio of his own there. A controversial figure, his views were out of sympathy with those of the Carracci circle but he did have supporters and his drawings were admired. Although influenced by a variety of artists his work remains highly individual: temperamentally he seems to have found more in common with the works of Correggio, Barocci and the Venetians than the Carracci.

JEAN HONORE FRAGONARD
French 1732-1806, painter and draughtsman

Born at Grasse in 1732, Fragonard died in Paris in 1806. As a child he was taken to Paris and there studied briefly with Chardin then entered the atelier of Boucher. In 1756 he went to the French Academy in Rome where he was influenced most by the baroque painters, and by Tiepolo; he also came into contact with Dutch and Flemish art. In 1761 he returned to Paris and was made a member of the Academy. At first he worked as a history painter, but returned to more intimate and erotic subjects. His patrons included Madame de Pompadour and Madame du Barry. With the French Revolution and the growing vogue for neo-classicism, to which he was unable to adapt, he was left destitute and died in poverty.

BATTISTA FRANCO
Italian c.1510-61, draughtsman, painter and etcher

Born in Venice about 1510, Franco died there in 1561. As a youth he went to Rome where he made drawings after the works of Michelangelo as well as copying Roman antiquities. In 1536 he moved to Florence under the patronage of Duke Cosimo I and in the 1540s was in Urbino working on the Cathedral and making designs for Maiolica. He was back in Rome in 1551 but had returned to his native Venice by the end of 1554. About 1560 he was commissioned by the Cardinal Patriarch Giovanni Grimani to decorate the family chapel in S. Francesco della Vigna and died the following year while working on these frescoes.

THOMAS GAINSBOROUGH
English 1727-88, painter and draughtsman

The son of a wool manufacturer, Gainsborough was born in Suffolk in 1727, and died in 1788. In 1740 he went to London to study painting and engraving with Gravelot. After his marriage in 1745 he set up as a portrait painter in Ipswich. In 1760 he was encouraged by friends to move to Bath, the fashionable spa, where he had great success with society portraits. In 1768 he was made a foundation member of the Royal Academy and in 1774 moved to London where, after a difficult period he was again inundated with commissions.

ARENT DE GELDER
Dutch 1645-1727, painter and draughtsman

Arent or Aert de Gelder was born at Dordrecht in 1645 and died in the same town at the age of eighty-two. He was first a pupil of Samuel van Hoogstraten, but about 1661 he went to Amsterdam where he entered Rembrandt's studio. He was to prove one of Rembrandt's ablest pupils and the master's late manner was a pervasive influence on de Gelder throughout his life. His subjects are often taken from Old Testament sources and frequently depict figures in oriental costume or exotic dress.

JACQUES DE GHEYN II
Flemish 1565-1629, draughtsman, engraver, painter and designer

The son of a stained-glass painter and miniaturist, he was the second of three generations of artists to be called Jacques de Gheyn. Born in Antwerp in 1565, he was apprenticed from 1585 to Hendrick Goltzius in Haarlem where he learned engraving. From 1595 he settled in The Hague where he mixed with a circle of scholars and distinguished men, obtaining major commissions from Prince Maurice and Prince Frederick Henry of Nassau. He was a noted flower painter and an acute observer of nature as is seen in his numerous studies of animals, birds and insects.

GIOVANNI FRANCESCO BARBIERI, IL GUERCINO
Italian 1591-1666, painter and draughtsman

Known by the nickname Guercino because of his squint, the painter was born at Cento which is between Bologna and Ferrara. He trained locally with Benedetto Gennari the Elder but was influenced early by the Carracci. He worked on frescoes at Casa Provenzale in Cento in 1614 and the following year in Bologna on the decorations of Casa Pannini: he visited Venice in 1618 and Ferrara in 1619. Pope Gregory XV, who had already commissioned him before his election, employed him in Rome where his major works were the Aurora frescoes for the Casino of Villa Ludovisi and an altarpiece for S. Petronilla. On the death of the Pope in 1623 he returned to Cento and settled there. Three years later he was in Piacenza where he completed the fresco decoration for the dome of the cathedral, and on the death of Guido Reni he returned to Bologna.

WILLIAM HOLMAN HUNT
English 1827-1910, painter, draughtsman and wood engraving designer

Holman Hunt was born in London in 1827 and died in 1910. In 1843 he entered the Royal Academy as a Probationer where he met Millais, and later became a friend of Dante Gabriel Rossetti who introduced him to Ford Madox Brown. With them in 1848 he founded the Pre-Raphaelite Brotherhood together with W. M. Rossetti, Woolner and Collinson. The following year he exhibited *Rienzi*, his first Pre-Raphaelite painting which was well received. The hostile reception of subsequent works in the next years made him consider abandoning painting. He made the first of several visits to the middle east in 1854 in which he sought to paint biblical scenes with total accuracy. He was totally committed to the ideals of the Brotherhood throughout his life, and works of the 1870s and 1880s like *The Shadow of Death* and *The Light of the World* caught the popular imagination. In his last years he was occupied in writing an account of the Pre-Raphaelite movement, published in 1905.

JEAN-AUGUSTE-DOMINIQUE INGRES
French 1780-1867, painter and draughtsman

Son of an ornamental sculptor, Ingres was born at Montauban in 1780 and after working in Toulouse entered David's studio in Paris in 1797. In 1800 he won the Prix de Rome, but only left for Rome in 1806. He remained in Italy until 1824 when, after a long and difficult period, he had success at the Paris Salon and returned to France. He returned to Rome in 1834 as Director of the French Academy, moving back to Paris finally in 1841. Early in his career Ingres arrived at a distinctive style which is always informed by his brilliant draughtsmanship.

JEAN ETIENNE LIOTARD
Swiss 1702-89, painter, draughtsman and engraver

The son of a French businessman, Liotard was born in Geneva in 1702. He showed an early talent for drawing and was sent to Paris to study with the painter and engraver Massé. In 1836 he accompanied the French Ambassador to the Holy See to Rome where he remained for two years before setting out for Constantinople. During his stay there he adopted Turkish dress and on his return to Europe was afterwards known as the Turkish painter. In 1742 he travelled to Vienna and in 1748 to Paris, then to London and Holland, all the time making portraits. He finally settled in Geneva and during the last thirty years of his life specialized in pastel portraits of distinguished citizens and visitors, frequently representing them in oriental dress.

AUGUSTE RODIN
French 1840-1917, sculptor and draughtsman

Rodin was born in Paris in 1840 and studied with Lecoq de Boisbaudran and Carpaux. Failing to get into the Ecole des Beaux-arts, he made a living from ornamental carving while attending sculpture classes at night, given by Barye. His entry for the 1864 Salon was refused. A visit to Italy in 1875-76, where he saw the work of Michelangelo, inspired him and freed him, he said, from 'academism'. The *Age of Bronze* made on his return from Italy caused a sensation by its realism. Some of the most famous of many sculpture commissions he received in the subsequent two decades are: the door for Musée des Arts Décoratifs – *The Gates of Hell*; *The Burghers of Calais*, and the monuments to Victor Hugo and Balzac.

GIULIO ROMANO
Italian c.1499-1546, architect, painter and draughtsman

Romano was born in Rome in about 1499 and died in Mantua in 1546. In Rome he became Raphael's chief assistant working with him on the Vatican Stanze and after Raphael's death, he was responsible for the completion of some of his unfinished works. In 1524 he left Rome for Mantua where he was to remain for the rest of his life. It was here that he designed his architectural masterpiece Palazzo del Tè for Federigo Gonzaga – among the first mannerist buildings. Here he became head of a large workshop, making designs for frescoes which were mostly executed by other artists, perhaps the most famous being those for the Sala de' Giganti with its illusionist effects.

SALVATOR ROSA
Italian 1615-73, painter, draughtsman and etcher

Salvator Rosa was born in Naples in 1615 and after a classical education turned to painting, studying first with a follower of Ribera, then with Aniello Falcone. In 1635, he left Naples for Rome where he became prominent in many activities, as painter, poet, satirist, actor and musician. In one satire he insulted the great Bernini and was obliged to leave for Florence shortly after, working there from 1640 to 1649, while attached to the Medici court. He returned to Rome in 1649 for good, still frequenting literary and scholarly circles, and established as great a reputation as he had enjoyed in Florence. His dramatic and arrogant temperament and his non-conformity endeared him to the 18th and early 19th century historians who saw him as the embodiment of a Romantic artist. His wild desolate landscapes, familiar through the wide circulation of his etchings, strongly influenced the later concept of the picturesque. He also shows a morbid interest in the bizarre and macabre, and in scenes of witchcraft which seem to have been inspired by treatises of the period.

ANDREA DEL SARTO
Italian 1486-1530, painter and draughtsman

Andrea Lanfranchi, known as Andrea del Sarto after his father's trade of tailor, was born in 1486 in Florence. He worked in Piero di Cosimo's workshop, later opening a workshop of his own with Franciabigio. He was court painter to Francis I, at Fontainebleau, from May 1518 until October 1519. On his return from France he spent some time in Rome, which he later fled because of plague in 1523 and returned to Florence, where he died of plague in 1530.

GIANDOMENICO TIEPOLO
Italian 1727-1804, painter, etcher and draughtsman

Son and pupil of Giovanni Battista Tiepolo, Giandomenico was born in Venice in 1727 and died there in 1804. He worked with his father and younger brother on the great fresco commissions, and accompanied them to Würzberg and Madrid. After his father's death in Madrid, he returned to Venice where, but for two years in Genoa, he remained for the rest of his life. He is perhaps most distinguished as a draughtsman; his subjects, ranging from classical to genre often exhibit a strong element of satire.

GIOVANNI BATTISTA TIEPOLO
Italian 1696-1770, painter, etcher and draughtsman

Tiepolo was born in Venice in 1696 – first a pupil of Lazzari, he was influenced by Piazzetta, but later turned to the works of Ricci and Veronese. He was given numerous secular and ecclesiastical commissions by his native city as well as by Udine, Milan, Bergamo and Vicenza. In 1750 he was invited to decorate the new Residenz of the Archbishop of Würzberg, for which he produced some of his greatest monumental frescoes. In 1762, he was summoned to Madrid by Charles III of Spain to carry out decorations for the Royal Palace and died there in 1770. He left an immense *oeuvre* of drawings which, like his frescoes, oil paintings and etchings, testify to his dazzling pictorial inventiveness.

ANDREA DEL SARTO
Italian 1486-1530

Head of a Laughing Boy
Black chalk
28.3 x 21.6cm Inv. no. 350/4
Provenance
P.H. Lankrink; Earl of Warwick 1896; J.P. Heseltine 1912; Henry Oppenheimer;
Oppenheimer sale, Christie's, London, 10 July 1936, no. 171; Felton Bequest, National
Gallery of Victoria 1936.
Exhibitions
Grosvenor Gallery, 1877, no. 554; 'Italian Drawings', Royal Academy, London, 1930,
no.522; Hermitage, Leningrad, 1978-79, no. 1.
Literature
H. Guinness, *Andrea del Sarto*, London, 1899, p. 32; B. Berenson, *The Drawings
of the Florentine Painters*, London, 1903, vol. II, no. 139; *Heseltine catalogue*, 1913, no. 4;
T. Borenius, 'Andrea del Sarto', *The Vasari Society* II, 1921, no. 5; F. Knapp, *Andrea del
Sarto*, Leipzig, 1907, p. 135; 1928, p. 118; A.E. Popham, *Catalogue of Italian Drawings
Exhibited at the Royal Academy*, London, 1930, no. 522; I. Fraenkel, *Andrea del Sarto,
Gemalde und Zeichnungen*, Strasbourg, 1935, p. 197; K.T. Parker, *Henry Oppenheimer
Collection*, 1936 , no. 171; B. Berenson, *I Disegni die Pittori Fiorentini*, Milan, 1961,
vol. II, no. 141B, fig. 765; S.J. Freedberg, *Andrea del Sarto*, Harvard, 1963, vol. I, p. 97, vol.
II, pl. 99; J. Shearman, *Andrea del Sarto*, Oxford, 1965, vol. II, p. 364; U. Hoff, *National
Gallery of Victoria*, 1973, p. 183; S. Dean, Leningrad, 1978, p. 11, no. 1; A.M. Petrioli
Tofani, *Andrea del Sarto Disegni*, Florence, 1985, no. xxiii, pl. xxiii.

Andrea del Sarto's fresco, *The Porta Pinti Madonna*, painted in 1521, one of the most
admired of 16th century paintings, no longer exists and is now known only from copies and
written descriptions, made before its final deterioration in the 18th century. A number of
studies for the painting have however survived, including this black chalk drawing for the
head of a laughing boy, which is a study for the head of the infant St John the Baptist. In the
painting, which takes its name from its location close to Porta Pinti where it was a popular
'shrine', we see the seated Madonna supporting the infant Christ with her right arm while
St John stands by her left shoulder. St John points to the Christ child who raises his hand
in blessing. This head study is psychologically complex, for the child is not simply a
laughing infant but one destined to be the Baptist, and there is, if not an air of sadness, an
ambiguity about his smile. John Shearman has noted Andrea's extraordinary empathy for
children and his skill in depicting them.[*]

Andrea del Sarto found chalk an ideal medium for drawing, allowing him a whole range
of visual effects, not least the soft, rich areas of sfumato which result from smudging the
chalk with a leather stump or with the fingers. Significantly, he did not make pen drawings,
no doubt finding that medium less sympathetic than chalk. In this drawing, the contours of
the child's face are strongly defined, as is the curly, tousled hair, but the plasticity of the
head and the modelling of the face depend almost entirely on the use of sfumato, the play
of shadows and highlights increasing the emotional intensity of the expression.

[*]J. Shearman, op. cit.

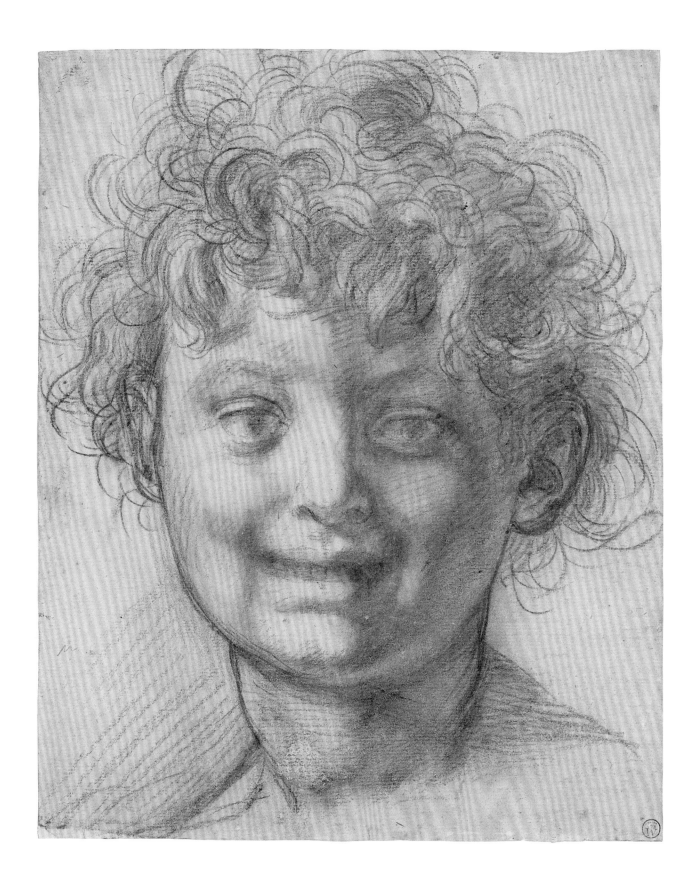

23

ANDREA DEL SARTO
Italian 1486-1530

Study for St John the Baptist
Verso: Study of Hands
Red chalk
38.5 x 19.5 cm Inv. no. 351/4
Provenance
Lechevallier-Chevignard sale, Hôtel Drouot, Paris, 1902, no. 15; J. P. Heseltine; Henry Oppenheimer; Oppenheimer sale, Christie's, London, 10 July 1936, no. 173; Felton Bequest, National Gallery of Victoria 1936.
Exhibitions
'Italian Drawings', Royal Academy, London, 1930, no. 525; Hermitage, Leningrad, 1978-79, no. 2.
Literature
B. Berenson, *The Drawings of the Florentine Painters*, London, 1903, vol. I, no. 137; F. Knapp, *Andrea del Sarto*, Leipzig, 1907, p. 135; F. di Pietro, *I designi di Andrea del Sarto negli Uffizi*, Siena, 1911, p. 24; *Heseltine catalogue*, 1913, no 2; T. Borenius, 'Andrea del Sarto', *The Vasari Society*, 1921, nos 3, 4; F. Knapp, *Andrea del Sarto*, 2nd edn , Leipzig, 1928, p. 118; I Fraenkel, *Andrea del Sarto, Gemalde und Zeichnungen*, Strasbourg, 1935, p. 180; K. T. Parker, *Henry Oppenheimer Collection*, 1936, no. 173; B. Berenson, *The Drawings of the Florentine Painters*, Chicago, 1938, vol. I, 279, vol. II, no. 141A; J. Shearman, *Andrea del Sarto*, Oxford, 1965, vol. II, pp. 364-5, pl.55; U. Hoff & M. Plant, *Painting Drawing Sculpture*, 1968, frontispiece; U. Hoff, *The National Gallery of Victoria*, 1973, pp. 83-84; S. Dean, Leningrad, 1978, p. 11, no. 2; A. M. Petrioli Tofani, *Andrea del Sarto Disegni*, Florence, 1985, no. xiii, pl. xiii.

This fine drawing in red chalk is a study for the central figure of St John the Baptist in Andrea del Sarto's fresco *The Baptism of the People* in the Chapel of the Scalzo, Florence. The painting is one of twelve monochrome frescoes narrating the life and death of the saint, a project which occupied del Sarto from about 1509 until 1526. It was commissioned by a brotherhood known as 'Campagnia della Scalzo' – the Barefoot Friars – who carried out charitable work, and whose second name – 'Discipliniati de San Giovanni Battista'- probably determined the subject of this fresco cycle.

The Baptism of the People, which shows St John baptising a kneeling youth while others stand by awaiting their turn, was completed early in 1517. It reflects a strong new influence at work on Andrea, that of Michelangelo, whose return to Florence in 1516 was no doubt the catalyst and whose cartoon for *The Battle of Cascina* seems to have been the stylistic model for the figures in this fresco.* The figure of St John however, derives from another work by Michelangelo, his St Matthew.† The Melbourne drawing is made from life, the model posed in a reminiscence of the St Matthew, a pose which remains unaltered in the final fresco.

*F. Knapp, op. cit.
†I. Fraenkel, op. cit.

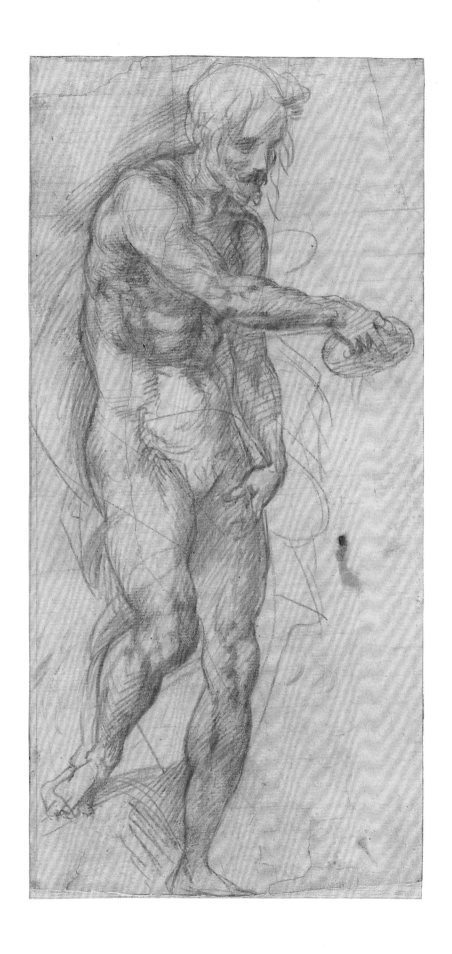

GIULIO ROMANO
Italian c. 1499-1546

The Holy Family of Francis I, St Elizabeth, St John and the Infant Christ
Cartoon fragment
Black and white chalk on prepared paper
69 x 52cm Inv. no. 587/4
Provenance
Sir John Ramsden; Christie's, 1932; R.E.A. Wilson; Howard Spensley; Howard Spensley
Bequest, National Gallery of Victoria 1939
Literature
Howard Spensley, MSS. Book 1, no. 605; O. Fischel, *Raphaels Zeichnungen*, Berlin,
1941; F. Hartt, *Giulio Romano*, Newhaven, 1958, p. 27; V. Thwaites, 'Two Drawings by
Giulio Romano', *Art Bulletin of Victoria*, 1976, pp. 52-57, fig. 7.

In 1518, a group of paintings was sent off from Rome as a Papal gift to the French King,
Francis I, these included *The Holy Family of Francis I* which is now in the Louvre. The work
had been commissioned from Raphael who assigned it to his assistants for execution. Vasari
mentions the painting in his *Lives** in connection with Giulio Romano and subsequent
critics have supported the view that it was largely the work of Raphael's chief assistant.†

Two fragments of the cartoon for this painting survive, one is the Melbourne drawing,
the other is in the Musée Bonnat, Bayonne. The cartoon marks the final drawing stage
before the painting is begun. Since a cartoon had to survive much workshop handling, it
was usually executed in black and white chalk on a heavy prepared paper. The Melbourne
cartoon is for the lower left to centre of the Holy Family composition, showing St Elizabeth,
St John and the Christ child. The source of the lively figure of the Christ child who reaches
up towards his mother, comes from Michelangelo's *Taddei Tondo* which in turn derives from
an antique putto.

If most critics have accepted Giulio as the painter largely responsible for *The Holy Family
of Francis I,* then agreement on the authorship of the drawings has been less unanimous.
Oskar Fischel attributes the painting and all the drawings, including the two cartoon
fragments, to Giulio Romano, while Frederick Hartt divides the drawings between Giulio
and another assistant, Raffaelino del Colle.†

* Vasari [1511-74], *Lives of the Painters Sculptors and Architects* – Giulio Romano.
†Passevant; Crowe & Cavalcaselle; Morelli; Berenson; Hartt.
‡O. Fischel, op. cit; F. Hartt, op. cit.

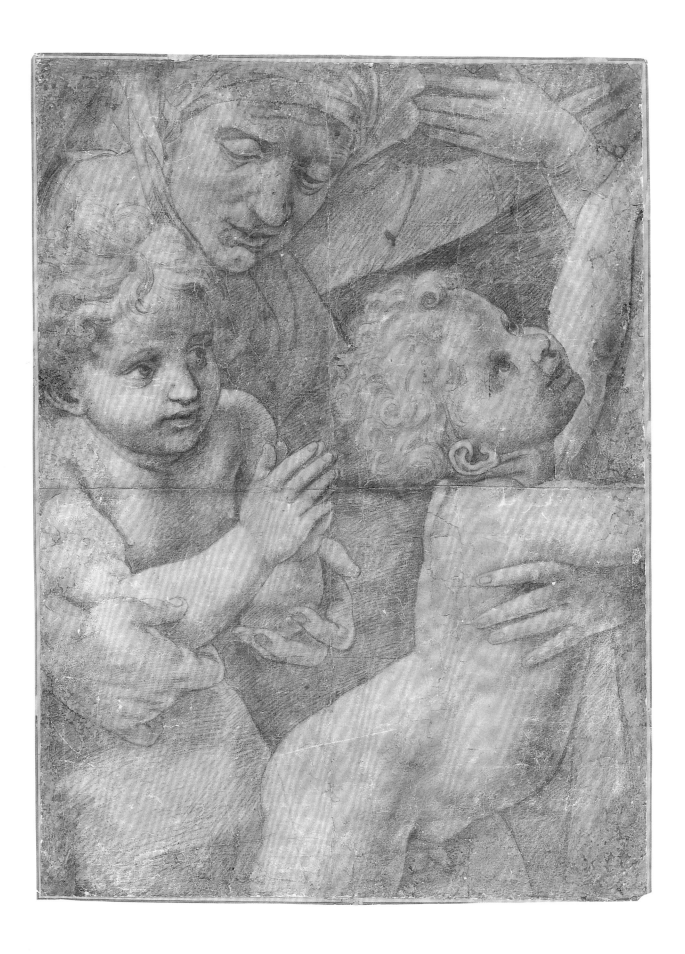

FRANCESCO MAZZOLA, PARMIGIANINO
Italian 1503-40

A Stag-hunt with a Huntsman sounding his Horn in the Foreground
Pen and brown ink and brown wash
26.2 x 20.5 cm Inv. no. 358/4
Provenance
Earl of Arundel; A. M. Zanetti; Baron Vivant-Denon; Sir Thomas Lawrence; Count
Nils Barck; A. W. Thibeaudeau; Marquis de Chennevieres; J. P. Heseltine; Henry
Oppenheimer; Oppenheimer sale, Christie's, London, 10 July 1936, no. 129; Felton
Bequest, National Gallery of Victoria 1936.
Exhibitions
Lawrence Gallery, Fourth Exhibition, 1836, no 44; Hermitage, Leningrad, 1978-79, no. 11.
Literature
Lawrence Gallery, Fourth Exhibition, 1836, no. 44; J. P. Heseltine, *Original Drawings by Old
Masters...Italian School,* London, 1913, no. 26; K. T. Parker, *Henry Oppenheimer Collection,*
1936, no. 129; A. E. Popham, *Drawings of Parmigianino,* London, 1953, p.l.ix; U. Hoff &
M. Plant, *Painting Drawing Sculpture,* 1968, p. 5, fig. 4; A. E. Popham, *Catalogue of Drawings
of Parmigianino,* Newhaven and London, 1971, vol. I, p. 115, no. 282, vol. III, pl. 372; U. Hoff,
National Gallery of Victoria, 1973, ill. p. 184; S. Dean, Leningrad, 1978, p. 13, no. 11;
D. Howarth, *Lord Arundel and his Circle,* Yale University Press [1985].

Parmigianino's brilliance as a draughtsman, which so astonished his contemporaries, is
vividly demonstrated in this virtuoso pen drawing. About eight hundred of his drawings
have survived, many of them from sketchbooks, but a few like this are highly finished, and
do not seem to relate to any known scheme, suggesting they are entirely independent
works. Their subjects are sometimes esoteric but even the everyday scenes seem to be
invested with some mystery. The huntsman is a vital, almost superhuman force, who seems
to burst upon the scene swept about with blowing garments and the elaborate serpentines
of his immense hunting horn.

A. E. Popham has dated this drawing from Parmigianino's second stay in Parma, that is,
sometime in the last decade of his life, 1530-39.* He has also drawn attention to the
similarity between this drawing and a black chalk study in the British Museum which was
made some ten years earlier in Florence, said to have been drawn from a terracotta at Casa
Buonarotti , and perhaps an inspiration for this drawing.† Among the highly finished
drawings, and perhaps contemporary with the Huntsman, is *Ganymede* in which a similarly
dominantly placed nude stands in the same posture, though this time with raised arms, and
again there is a sudden change of scale from foreground to middle distance.‡ This drawing
is clearly influenced by engravings, not only in the strong undulating, unbroken contours,
but in the delicate hatching which describes the muscles of the torso and the swirling
garments.

*A. E. Popham, 1971, loc. cit.
†A. E. Popham, *Italian Drawings in the Department of Prints and Drawings,* British Museum, 1967, no. 73.
‡*Ganymede,* private collection; A. E. Popham, no. 752.

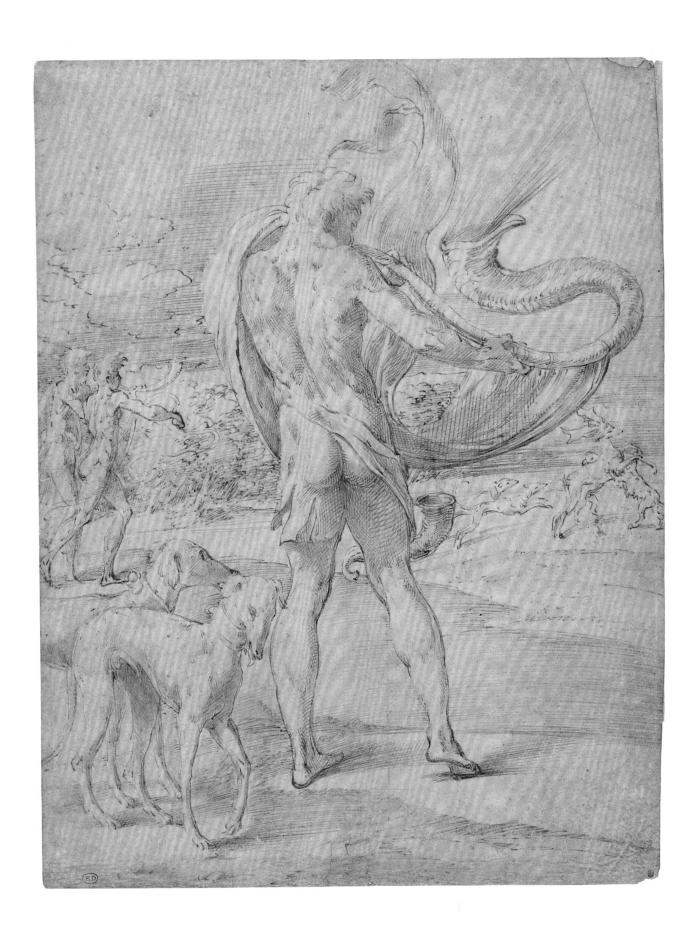

BATTISTA FRANCO
Italian c. 1510-61

Virgin and Child with Magus
Pen and bistre
20 x 21.1 cm Inv. no. 1278/3
Provenance
William Esdaile; William Mayor; R.C. Sticht; Felton Bequest, National Gallery
of Victoria 1923.
Exhibitions
Hermitage, Leningrad, 1978-79, no. 18.
Literature
R. Gaston, 'A Drawing by Battista Franco and its Venetian context', *Art Bulletin of Victoria*
18, 1977, p. 26; pp. 25-32, fig. 1; S. Dean, Leningrad, 1978, p. 15, no. 18.

This drawing by Battista Franco was identified in 1977 by Dr Robert Gaston as a study for *The Adoration of the Magi*, for the Grimani Chapel in S. Francesco della Vigna in Venice, on which Franco was working at the time of his death.* The commission was taken over by the young Federico Zuccaro who is known to have made a number of changes of his own to the final composition.

Already in this early study Franco had fixed the positions of the three central figures, the Virgin, Child and the first of the three Magi. In a final highly finished drawing of the composition which Franco had squared up for enlargement,† he made only one crucial change to the position of one of these figures, and that is already indicated, if faintly, in this early study. We see that he has had second thoughts about the direction the child would face, and though in the Melbourne drawing he looks back towards his mother, a pentimento suggests that he was already considering the alternative of the child looking at the gift which the wise man offers. In the final drawing, it is the second alternative, the child facing the Magus, which he chooses as compositionally a more satisfactory solution. Although the drawing must date from the last year of Franco's life, it still shows the delicacy and refinement of his earliest pen drawings.

*R. Gaston, op.cit.
†Battista Franco, *The Adoration of the Magi*, Uffizi, Florence.

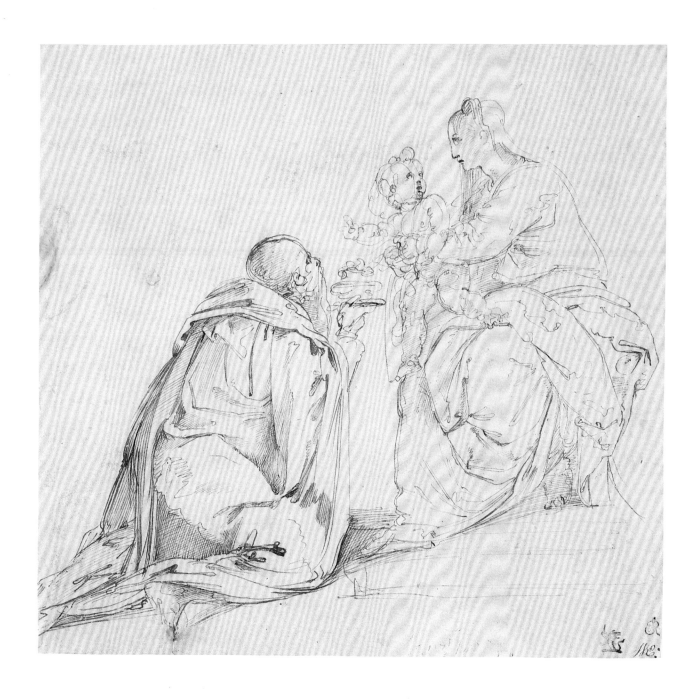

FEDERICO BAROCCI
Italian 1553-1612

The Annunciation
Verso: Fleeing Figures
Pen and brown ink and wash over black chalk on tinted paper, laid down
Inscribed in pencil on backing: F. Baroccio
25.8 x 21.2 cm Inv. no. P19/1972
Provenance
Sir Thomas Lawrence; Lord Francis Egerton, 1st Earl of Ellesmere; Sotheby's,
London, 5 December 1972, no. 100; Felton Bequest, National Gallery
of Victoria 1972.
Exhibitions
Hermitage, Leningrad, 1978-79, no. 3.
Literature
S. Dean, Leningrad, 1978, p. 11, no. 3.

The drawing is a study for the painting *The Annunciation* which was made for the Ducal
chapel of Francesco Maria II della Rovere in the Basilica of Loreto, in Urbino, between
1582 and 1584 but is now in the Pinacoteca in the Vatican. Barocci also made an etching of
the same subject (Bartsch xvii 2.1), an impression of which can be seen in the Gallery's
collection.

Barocci, a prolific draughtsman, made numerous preparatory drawings for his paintings
through which we can trace the development of his compositions and observe the modific-
ations and changes he made as a work progressed. By the time he made this pen and wash
drawing, he had already resolved the main elements of the composition, had decided on the
placing of the principal figures and determined their gestures, but in some key ways the
idea is still evolving.

An earlier study, now in Copenhagen, shows the Virgin with her hands clasped in prayer,
but here this gives way to a more dramatic concept, as startled, she thrusts aside the book
and raises her arm in a gesture of alarm. The figures are caught mid-movement which gives
the composition an air of restlessness, even agitation. This Barocci resolves in the final
composition by making the subtlest adjustments. The angel, who dominates the drawing,
now gently extends his arm towards her, creating a new harmony between the two figures
and restoring an element of serenity. Details of the room and of the view from the window,
only indicated in the drawing, emerge more elaborately but little changed. The room is
now enclosed, and the window, smaller, looks out appropriately, on a prospect of Palazzo
Ducale. The drawing is made almost entirely in wash on a tinted paper, while the pen is
used mostly to reinforce a gesture or articulate a detail.

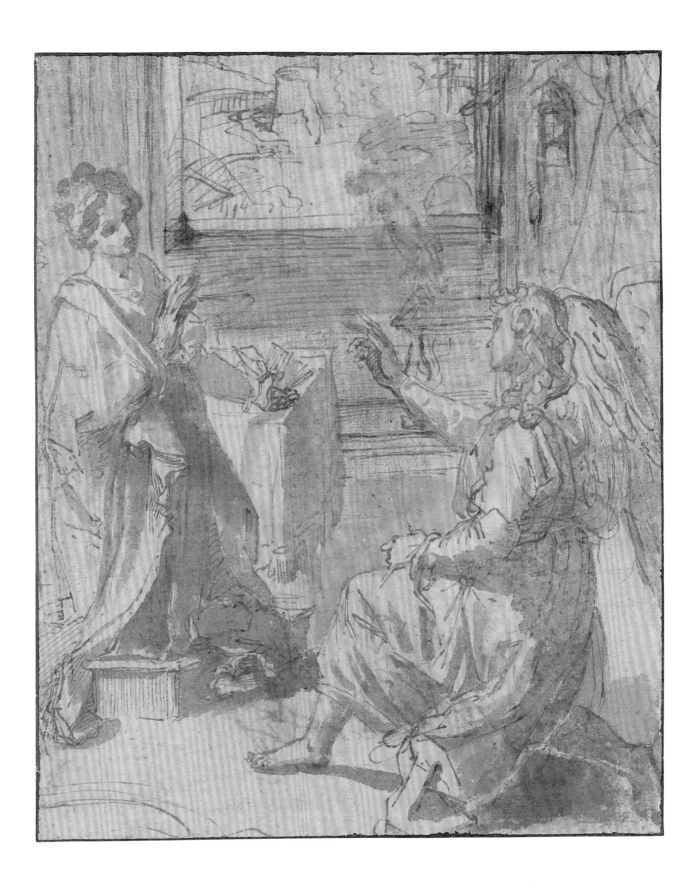

33

FEDERICO BAROCCI
Italian 1553-1612

Head of a Bearded Man looking down
Red and black chalk and pastel on blue-green faded paper
34.8 x 24.9 cm Inv. no. 562/8
Provenance
Ettingham Park Album (?); Colnaghi; R.E.A. Wilson; Howard Spensley; Howard Spensley
Bequest, National Gallery of Victoria 1939.
Exhibitions
Hermitage, Leningrad, 1978-79, no. 4.
Literature
Howard Spensley, MSS. Book I; p.109, no 580; S. Dean, Leningrad, 1978, p. 11, no. 4.

Barocci's biographer, Bellori, writing some sixty years after the artist's death tells us that he
learned the technique of pastel drawing from the works of Correggio which were brought
from Parma to Urbino. Recent scholars have questioned this, for there are neither extant
works in pastel by that artist nor any other record of his use of the medium.* Further, the
influence of Correggio on Barocci seems to be one of approach rather than technique
and scholars have been more inclined to suggest that it was the works of the Venetians
which inspired Barocci's pastels, in particular those of a noted exponent of the art,
Jacopo Bassano.†

 This study is almost certainly for a figure composition and is drawn from life. It was
Barocci's method to make studies of details – a head, an arm or hand – in pastel, often
when the painting was under way, working out the lighting, the tonal values and sometimes
the actual colours for the final composition. The choice of coloured paper was not
arbitrary; it supplies both an intermediary tone between pastel and black and red chalk and
is sometimes also the colour used in the final work. Here the paper provides a shadowy
tone, the light of a candle or a lamp illuminating a part of the face which is highlighted in
pink and white pastel.

*E. P. Pillsbury & L. Richards, *The Graphic Art of Federico Barocci*, Yale, 1978.
†ibid.; D. Degrazia, *Correggio and his Legacy*, Washington, 1984.
‡Barocci's pastels were greatly admired by French 18th century masters.

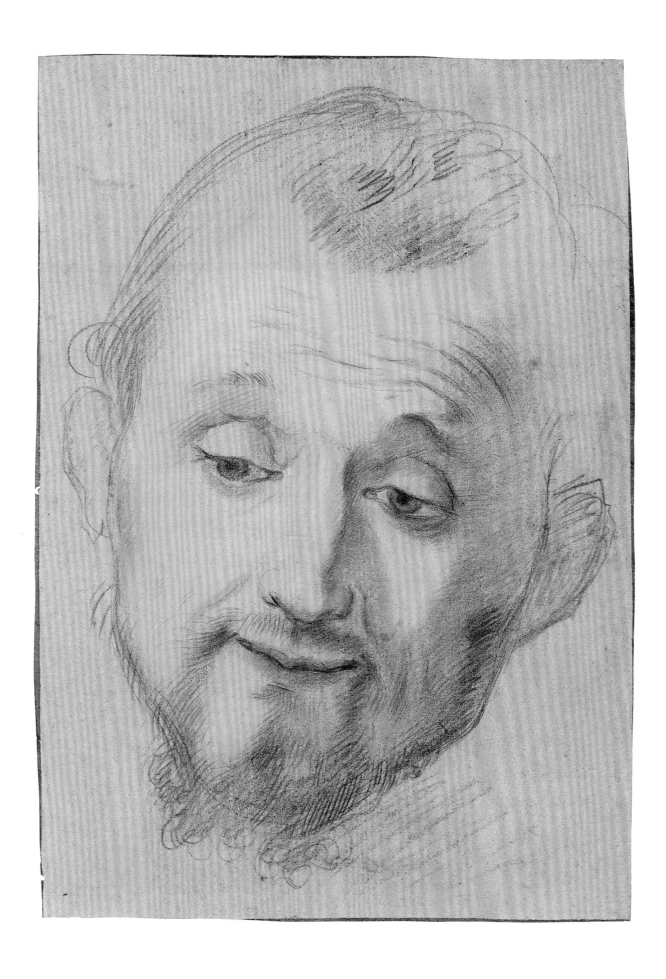

ANNIBALE CARRACCI
Italian 1560-1609

Study for an Ignudo
Black chalk heightened with white, squared up for enlargement in black chalk, on faded blue paper
37.7 x 32.6cm Inv. no. 10/1972
Provenance
Sir Thomas Lawrence; Lord Francis Egerton, 1st Earl of Ellesmere; Sotheby's, London, 11 July 1972, no. 66; purchased by the National Gallery of Victoria with the aid of a State Government Grant 1972.
Exhibitions
'17th Century Art in Europe', Royal Academy, London, 1938, no. 379; 'Old Master Drawings', Leicester, 1952, no. 13; 'Old Master Drawings', Royal Academy, London, 1953, no. 131; 'Drawings by the Carracci and Other Masters', Colnaghi's, London, 1955, no. 17; 'Artists in 17th century Rome', Wildenstein & Co., 1955, no. 23; 'Mostra dei Carracci, Disegni', Bologna, 1956, no. 178; 'The Carracci, Drawings and Paintings', Newcastle-upon-Tyne, 1961, no. 134; Hermitage, Leningrad, 1978-79, no. 8.
Literature
Bridgewater House catalogue, no. 14; H. Bodner, 'Drawings by the Carracci', *Old Master Drawings*, March 1934, pl.60; A. E. Popham, '17th century Art in Europe, The Drawings', *The Burlington Magazine*, January 1938, p. 14, pl.1A; R. Wittkower, *Drawings of the Carracci at Windsor*, London, 1952, pl.139, under no. 310; P. A. Tomory, *The Ellesmere Collection*, Leicester, 1954, no. 49; J. R. Martin, *The Farnese Gallery*, Princeton, 1965, p. 223, fig. 217; *The Ellesmere Collection of Drawings by the Carracci*, Part 1, Sotheby's, London, 1972, no. 66; S. Dean, Leningrad, 1978, p. 12, no. 8.

Late in 1594 Annibale Carracci and his brother Agostino were invited to Rome by Cardinal Odoardo Farnese to undertake decorations on the Farnese Palace. By 1595 Annibale had already settled in Rome and begun work on the ceiling of the Camerino, which was completed about 1597. He then embarked on the complex program for the ceiling of the Gallery destined to be his greatest achievement. In Rome he was able to study at first hand the works of Michelangelo and Raphael as well as those of antiquity. In planning the Farnese ceiling it is clear that he studied its great forerunner, the Sistine ceiling, and the idea of incorporating the ignudi, or naked youths, into the design was certainly inspired by their precursors, Michelangelo's so called slaves. The massive youths who adorn the Farnese ceiling seem to energize their environment as if their explosive energy can hardly be contained.

In this most celebrated study for the ignudo who sits to the left of the fresco *Venus and Anchises*, we see that his pose has been inspired not by one of the Sistine slaves but by the figure of the prophet Jonah. Although essentially a life drawing, it is informed by Annibale's knowledge of the antique and of the renaissance concept of the ideal. The model has been placed well above eye level for this drawing and is lit from the lower left. The light articulates the rippling muscles of the torso and massive limbs. It is drawn precisely as the figure will appear in the final fresco, and is squared up for enlargement. This aptly demonstrates Annibale's practice of resolving the technical problems of foreshortening and lighting at the life drawing stage. This remarkable drawing is undoubtedly one of the masterpieces of Annibale's *oeuvre*.

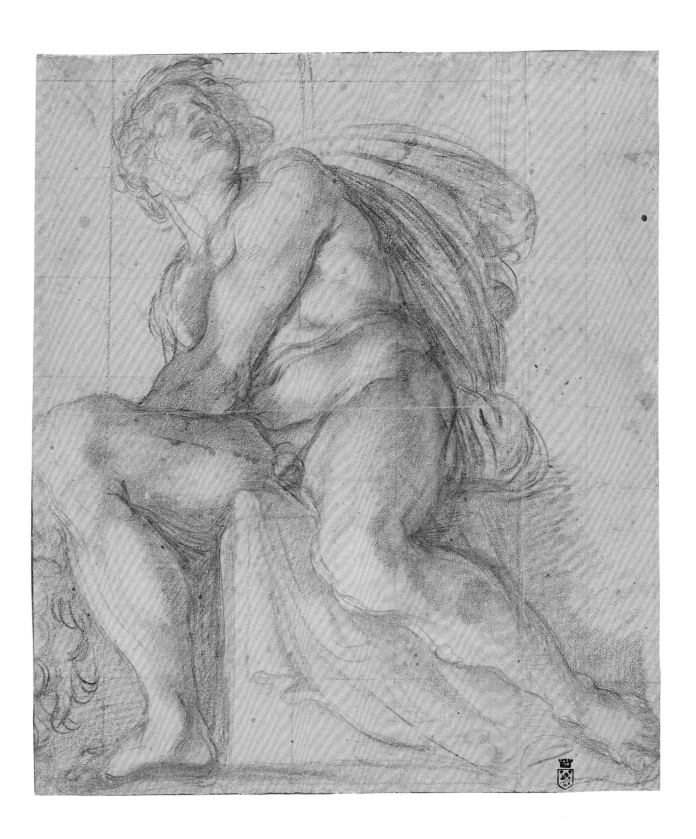

37

ANNIBALE CARRACCI
Italian 1560-1609

A Naked Warrior Lying on the Ground
Black chalk on blue paper
26 x 46.6cm Inv. no. 592/4
Provenance
R. E. A. Wilson; Howard Spensley; Howard Spensley Bequest, National Gallery of
Victoria 1939.
Exhibitions
Hermitage, Leningrad, 1978-79, no. 9.
Literature
Howard Spensley, MSS. Book 1, p. 80, no. 610; J. Anderson, 'Speculations on the Carracci
Academy in Bologna', *The Oxford Art Journal* 3, October 1979, pp. 15-20; S. Dean,
Leningrad, 1978, p. 13, no. 9.

This black chalk drawing came from the collection of Howard Spensley, where it was
attributed to Barocci under whose name it appears in the Spensley catalogue. It was Arthur
Popham who identified it as a study by Annibale Carracci for a fresco in Galleria Farnese
in Rome. The subject is the prone warrior seen to the right of the fresco *The Combat of
Perseus and Phineas,* at the north end of the Farnese Gallery, where the figure is partly
obscured by the straddling legs of Phineas and one of his men. One of these legs is
indicated in the drawing, cutting across the thighs of the prostrate figure.

After completing the Gallery ceiling, Annibale turned his attention to the decoration
of the walls in a scheme signalling a distinct change of key, for whereas the ceiling motifs
celebrate hedonism and sensuality, the wall decorations describe the triumph of virtue over
vice.* The change is as much one of style as subject matter. The growing austerity of these
late frescoes and a certain 'dryness' detected in the drawing, has led some critics to
attribute both the *Perseus* frescoes and the drawings to other hands. Tietze suggested
Domenichino, but this has been rejected by other scholars.† The alleged 'falling off'
coincides with a period of depression in Annibale's life, stemming from his maltreatment
by his patron Cardinal Odoardo and his gross under-payment for the Farnese ceiling.

Although the study for *A Naked Warrior* lacks the drama and some of the vitality of the
Ignudo it is nevertheless a fine and acutely observed life drawing which retains a directness
and fluency, perhaps not present in all the Perseus studies.

*P. Bellori [1615-96], *The Lives of Modern Painters, Sculptors & Architects*, Rome, 1672.
†J. R. Martin, op. cit.; Pope-Hennessy, Wittkower, Mahon and Martin reject the attribution to Domenichino and support
Annibale's authorship.

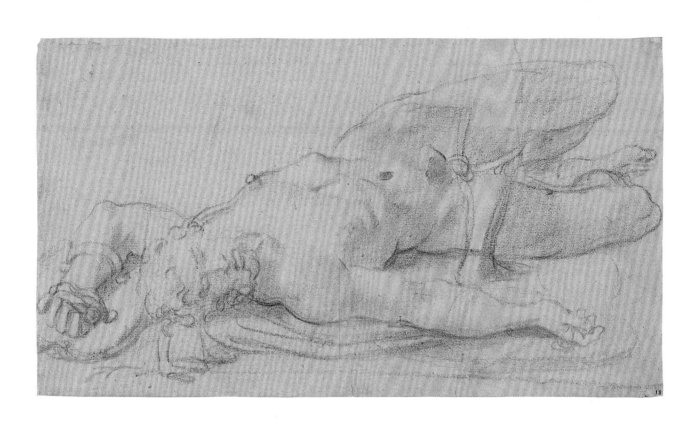

ANNIBALE CARRACCI
Italian 1560-1609

Landscape with a Watermill
Pen and brown ink over traces of red chalk
16.5 x 14.5 cm Inv. no. P.11/1972
Provenance
Everhard Jabach; Pierre Crozat; Pierre-Jean Mariette; Count Moriz von Fries; Sir Thomas Lawrence; Lord Francis Egerton, 1st Earl of Ellesmere; Sotheby's, London, 11 July 1972, no. 71; purchased by the National Gallery of Victoria with the aid of a State Government Grant 1972.
Exhibitions
Lawrence Gallery, London, no. 97; 'Old Master Drawings', Leicester, 1952, no. 18; 'Drawings by the Carracci and other Masters', Colnaghi's, London, 1955, no. 20; 'The Carracci, Drawings and Paintings', Newcastle-upon-Tyne, 1961, no. 102.
Literature
Bridgewater House catalogue, no. 26; P. A. Tomory, *The Ellesmere Collection*, Leicester, 1954, no. 67; *The Ellesmere Collection of Drawings by the Carracci*, Part 1, Sotheby's, London, 1972, no. 71.

This drawing has a particularly distinguished provenance. Its 17th century owner was Everhard Jabach c.1610-95 who had one of the finest of drawing collections, which included outstanding examples by the Carracci. About 1666 he decided to have his best drawings reproduced as engravings, including this small landscape: its meticulous manner of drawing seems already to anticipate the engraving process.* Subsequently the drawing passed through the cabinets of the great French collectors, Crozat (1665-1740) and Mariette (1694-1774) to Count Moriz von Fries (1777-1826) and the English painter Sir Thomas Lawrence (1769-1830). On Lawrence's death his collection was offered to George IV and to the British Museum but was finally dispersed, some 112 drawings going to the first Earl of Ellesmere.

Although Annibale was not primarily a landscape painter, he did make landscape drawings from nature, bringing to bear the same acute powers of observation we see in his life studies. Peter Tomory has dated this delicate drawing just before 1605.† Sadly, it has been disfigured by the insensitively placed Ellesmere collector's mark in the lower right.

*No. 39 Recueil de 283 Estampes...d'après les Dessins des Grand Maîtres que possedoit autrefois M Jabach et qui depuis ont passé au cabinet du Roy, Paris, 1754.
†P. Tomory, op. cit.

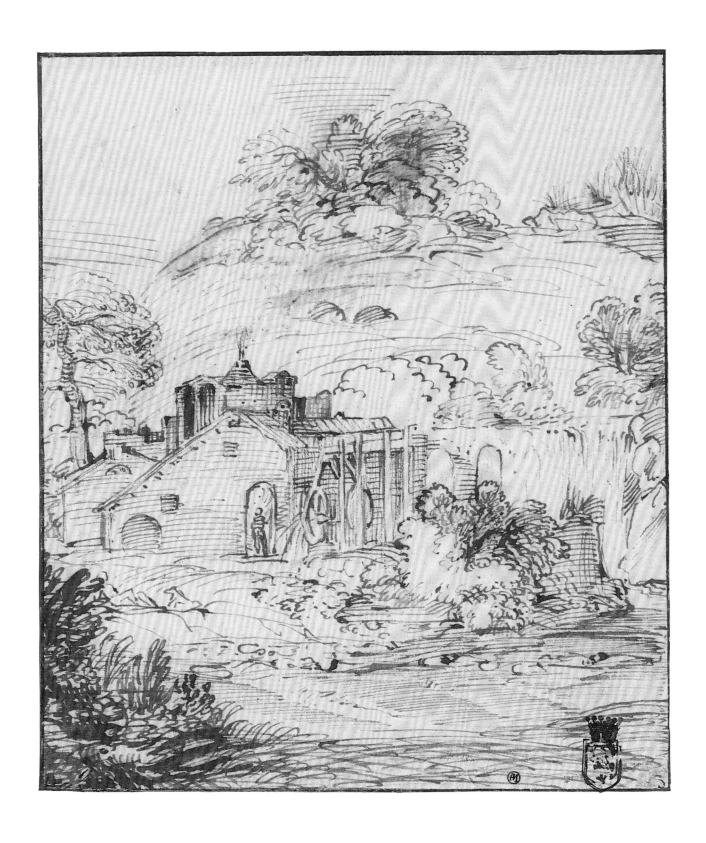

PIETRO FACCINI
Italian c. 1562-1602

The Head of a Woman

Black chalk heightened with white on grey-green paper
Inscribed l.l.: Pietre Facini Bologniesco in an old hand;
l.r.: di Pietro Facini
28.8 x 22.2cm Inv. no. 560/4
Provenance
Howard Spensley; Howard Spensley Bequest, National Gallery of Victoria 1939.
Exhibitions
'17th Century Art', Royal Academy, London, 1938, no. 360; 'The Art of Drawing',
1964-65, no. 48; Hermitage, Leningrad, 1978-79, no. 17.
Literature
Howard Spensley, MSS. Book 1, p. 110A, no. 578; U.Hoff, *The Art of Drawing,* 1964,
no. 48; S.Dean, Leningrad, 1978, p. 15, no. 17.

Faccini's fondness for exaggerated modelling and theatrical effect is evident in this study,
though the drawing is restrained and the whole accomplished with a remarkable economy
of means. The study is probably made from life, but we do not know if it relates to a
painting. The head has been set at such an angle that the face is foreshortened, while the
source of light, perhaps from a candle or lamp, is set below, so that it illuminates the base
of the nose and flattens the contours of the face. It is a virtuoso drawing, both spontaneous
and confident.

Faccini experimented with a variety of drawing media and techniques but frequently
used, as here, a greasy black chalk on rough textured paper, with white chalk to define the
highlights. The texture of the paper gives the greasy chalk a soft blurred effect, a feature
which the artist exploits in many of his drawings.

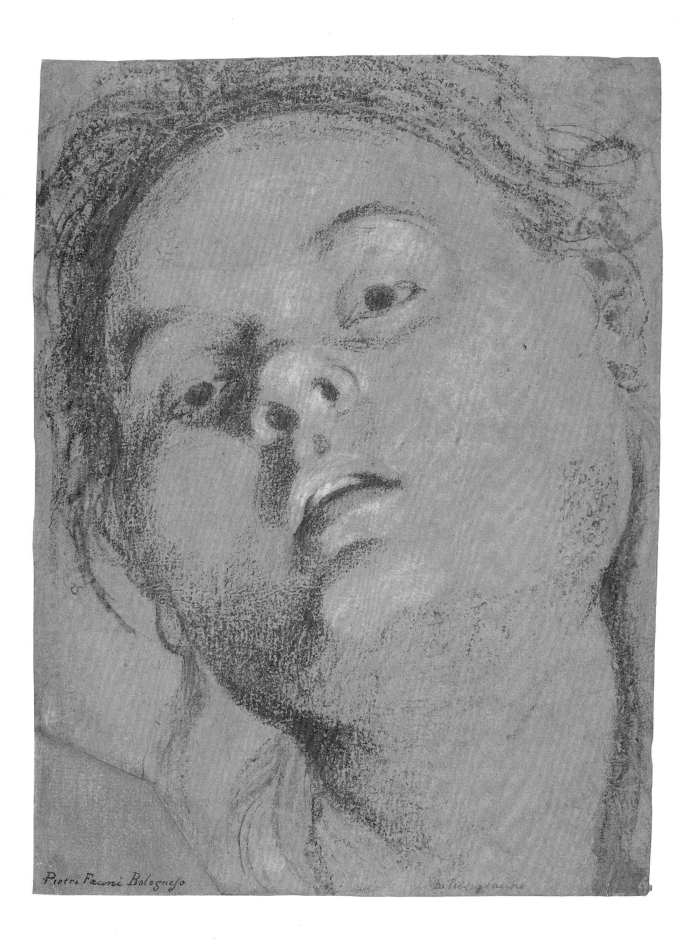

Pietri Facini Bolognese

GIOVANNI FRANCESCO BARBIERI, IL GUERCINO
Italian 1591-1666

Hercules slaying the Hydra
Verso: Sheet of Studies of Hercules slaying the Hydra, Heads in profile and a warrior
Pen and brown ink and wash (recto), brown ink (verso)
29.9 x 19.9cm Inv. no. P.12/1972
Provenance
Jean-Baptiste-Joseph Wicar; Sir Thomas Lawrence; Lord Francis Egerton, 1st Earl of
Ellesmere; Sotheby's, 11 July 1972, no. 94; purchased by the National Gallery of Victoria
with the aid of a State Government Grant 1972.
Exhibitions
Lawrence Gallery, London,1836,no. 99 as 'Annibale'; 'Old Master Drawings', Leicester
Museum, 1952, no. 11; 'Drawings by the Carracci and other Masters', Colnaghi's,
London, 1955, no. 43; 'Mostra del Guercino, Disegni', Bologna, 1967, no. 3; Hermitage,
Leningrad, 1978-79, no. 6.
Literature
Bridgewater House catalogue, no. 67 as 'Annibale'; H. Bodmer, 'Drawings by the Carracci,'
Old Master Drawings, March 1934, pp. 52, 53, pl. 52 as 'Lodovico'; D. Mahon, 'Notes
on the Young Guercino 1 in Cento and Bologna,' *The Burlington Magazine,* March 1937,
p. 118, p. iic; P.A. Tomory, *The Ellesmere Collection,* Leicester, 1954, no. 116; R. Roli,
I fregi centesi del Guercino, Milan,1972, p. 48, pl. 10; *The Ellesmere Collection of Drawings
by the Carracci and other Bolognese Masters,* Sotheby's, London ,no. 94; S. Dean, Leningrad,
1978, p. 12; no. 6.

This drawing was made for one of Guercino's earliest commissions, the scheme for the
Casa Provenzale in his native Cento, which dates from 1614 when he was twenty-three
years old. It is for the large chiaroscuro figure of Hercules slaying the Hydra, designed for
the frieze, which appears with the similarly large-scale figures of Jupiter and Neptune.
Each is set in a painted alcove from which they seem to project as if their energy and
violence cannot be contained within the architectural space. The clever illusionism of the
scheme is achieved by illuminating the figures as if from a strong light source below and by
throwing the shadows of their gestures on to both the wall behind them and even on to the
edge of the ceiling, as if the figures were indeed three-dimensional.

In this drawing, Hercules's right arm pierces the upper pen-line border of the sheet
as if breaking free of the alcove, and the shadow of his knee and arm are thrown to the left
as if on to a wall behind. Although the ink has faded we can still appreciate Guercino's
fluid, subtle line and the light and dark accents which define the massive limbs and torso
and articulate the serpentine swirls of the multi-headed hydra. The monster is more
confined than in the final frieze, in which an evil head projects over the pediment – a study
for it is seen in the lower right of the sheet – and a tail lashes upwards in a flourish towards
Hercules's raised club. Towards the right margin is a small-scale study for the chiaroscuro
figure of the god, Jupiter.

When this drawing was shown at the Lawrence Gallery exhibition of 1836 it was attributed
to Annibale Carracci. It was not until 1937 that Denis Mahon was able to identify it beyond
doubt as the work of Guercino. The frieze at Casa Provenzale was recorded but had been
thought lost until Mahon himself discovered it still intact under a false ceiling which had
been put there in the 19th century. *

* D. Mahon, op.cit.

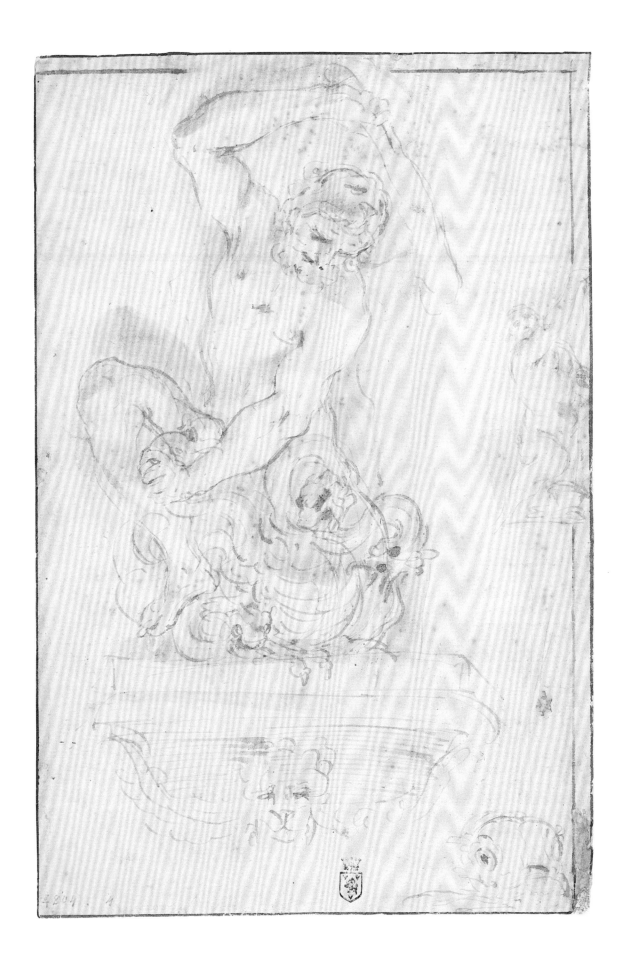

GIOVANNI BENEDETTO CASTIGLIONE
Italian c.1610-c.65

Tobit Burying the Dead
Brush drawing in red and pale-blue paint, touches of darker red, and pale and dark brown,
on beige paper
40.5 x 54.2cm Inv. no. P.85/1970
Provenance
Nathaniel Hone; Colnaghi; Herbert Bier, London; National Gallery of Victoria 1970.
Exhibitions
'Exhibition of Old Master Drawings', Colnaghi's, London, 13-30 June 1967, pl.X;
'Giovanni Benedetto Castiglione, Master Draughtsman of the Italian Baroque',
Philadelphia Museum of Art, 17 September-28 November 1971, no. 92; Hermitage,
Leningrad, 1978-79, no. 10.
Literature
A. Blunt, 'A Poussin-Castiglione Problem', *Journal of the Courtauld and Warburg Institute*
III, 1939-40, pp. 142-7; U. Hoff, 'Tobit Burying the Dead: A Newly Acquired Drawing by
G. B. Castiglione (1611?-1665?)', *Art Bulletin of Victoria,* 1970-71, pp. 19-20, fig. 1; A. Percy,
Giovanni Benedetto Castiglione, Philadelphia, 1971, p. 113, no. 92; S. Dean, Leningrad, 1978,
p. 13, no. 10.

Although Castiglione used the traditional techniques of pen and ink and pen and wash, his
most distinctive method of drawing was entirely his own creation. For an artist credited
with the invention of the monotype it is perhaps less surprising that he should experiment
in this way. Using a brush dipped in oil then in dry pigment he drew directly on to untreated
paper, the effect varying from a liquid line to dry accented passages almost chalk-like in
quality. His colours vary from a rich amber to dark angry reds and in some late works he
often uses more colour. Rubens and van Dyck, whose work Castiglione knew so well, had
made oil sketches on panel to which these drawings bear some general resemblance, but
Castiglione applies oil and pigment on to paper to unique effect.

The drawing, with its graphic abbreviations and apparent rapidity of execution, its
variety of reds, browns and touches of blue on beige paper has all the hallmarks of
Castiglione's late drawing style, and dates from the last ten years of his life.* It marks the
artist's return to the subject of Tobit, which he had used in the 1640s† in much the same
way that he returned to the earlier theme of Noah in these years. The subject, 'Tobit
Burying the Dead' comes from The Book of Tobit in the Apocrapha, I:16-19. It tells of an
Israelite, Tobit, held captive in Nineveh, where his steadfast observance of the rules of his
own religion so impresses the King that he is allowed a degree of freedom to give alms and
succour to his fellow captives. When the King dies and is replaced by the infamous
Sennecherib, persecution of the Israelites again begins and Tobit falls foul of authority.
An edict forbids the burial of any murdered captives, but Tobit makes clandestine plans
to bury them by night. The burial is seen by a Ninevite who reports it to the King.

Castiglione chooses to depict not the revelation of the Ninevite, who is apparently one of
the lurking figures on the stylobate, but the actual internment, as Tobit supervises the burial
of the corpse amid the ruins of the decayed garden. It is the macabre and romantic aspect
of the subject that interests him. His architectural setting derives from Poussin and appears
already in a 1640s version of the subject, as do the Herm, the sarcophagus and details of the
garden. These features reappear in later versions of the subject.‡ The drawing does not
appear to be a study for a painting, a characteristic of the late brush drawings, which are
mostly independent works.

*A. Percy dates the drawing 1655-60.
†Cleveland Museum of Art, A. Percy, op. cit., no. 15; Chatsworth, Devonshire Collection, A. Percy, op. cit., no. 16.
‡The 1640s version is in the Cleveland Museum of Art; the later one is in the Witt Collection, Courthauld Institute Gallery,
London.

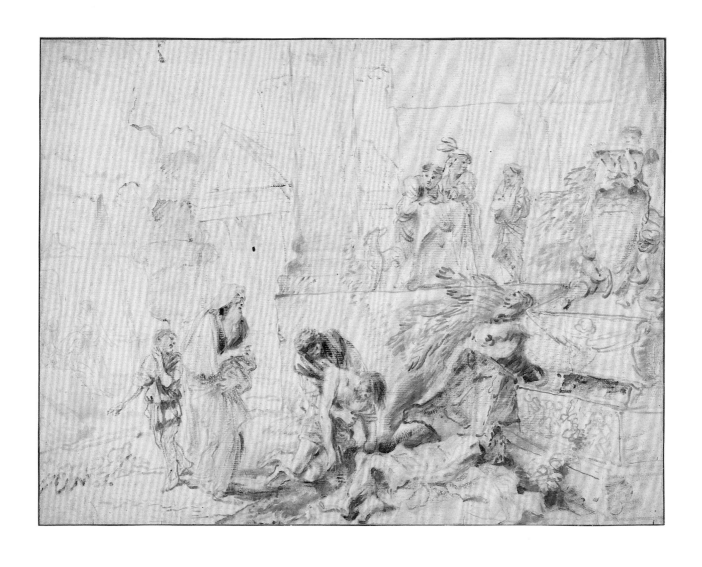

SALVATOR ROSA
Italian 1615-73

Sheet of Studies
Pen and brown ink
27 x 17.8 cm Inv. no. 1278/3
Provenance
F. Abbott, Edinburgh; R.C. Sticht; Felton Bequest, National Gallery of Victoria 1923.
Literature
M. Mahoney, *The Drawings of Salvator Rosa*, New York and London, 1977, vol. I, p. 687, vol. II, pl. 80.11; I. Zdanowicz, 'A Note on Salvator Rosa's "Study for the Death of Empedocles"', *Art Bulletin of Victoria* 20, pp. 45-50, fig. 1.

The three studies on this sheet are possibly all unrelated and only one of them can be positively identified as the subject of a known painting. The plummeting figure to the right of the sheet is a study for the painting *Empedocles Leaping into Etna,* and dates from the 1660s.* It is a rare subject in painting, and typifies Rosa's search for themes from obscure texts. The story is told by Diogenes Laertius, a historian of the 3rd century A.D. who wrote biographies of ancient philosophers. Among these is the Sicilian, Empedocles, whose learning and magical healing powers – which extended to raising the dead – so impressed local townspeople that they began to believe his claims to immortality. To fuel their belief he decided to vanish mysteriously and without trace by throwing himself into the volcanic crater of Mount Etna. Unfortunately, one of the bronze sandals which he customarily wore, was hurled out of the fiery crater providing evidence of his very mortal end and of his false claims to immortality.

There are a number of related drawings on this theme cited by Michael Mahoney.† The source of the drawing below depicting two female nudes is a northern print. This was first noted by Irena Zdanowicz who saw that the subject came from Hans Baldung de Grien's chiaroscuro woodcut, *The Witches* of 1510 (Bartsch VII/55).‡ The drawing reverses the figures and she has suggested that Rosa knew the subject from an Italian copy which also shows the figures in reverse. The third study to the left in which a winged figure points over a cliff edge at some mystery or terror below, to the dismay and horror of a second figure, is a characteristic Rosa scenario but the theme has not yet been identified.§ This sheet can be dated from the last years of Rosa's life both from its connection with the Empedocles painting and from the very free, impetuous drawing style.

*Lord Sommers collection exhibited as no. 44 in 'Salvator Rosa', Arts Council, London, 1973.
†M. Mahoney, op. cit., pp. 683-8.
‡I. Zdanowicz, op. cit.
§There is a related drawing in Leipzig with a similarly winged figure pointing over a precipice, see Mahoney, vol. I, no. 80.12, p. 687.

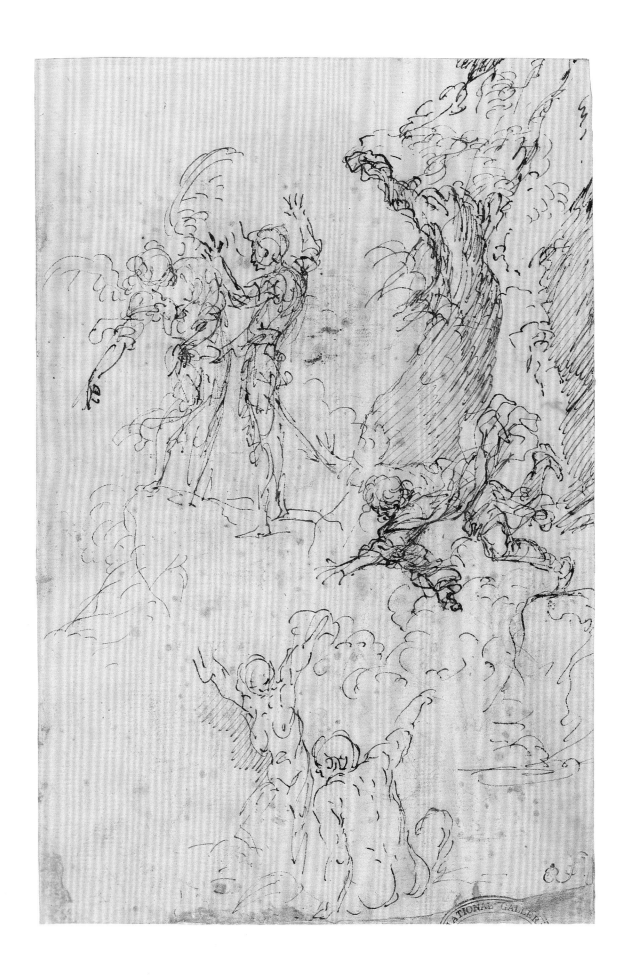

GIOVANNI BATTISTA PIAZZETTA
Italian 1683-1754

Head of a Boy
Black and white chalk
39 x 31.5 cm Inv. no. 567/4
Provenance
Howard Spensley; Howard Spensley Bequest, National Gallery of Victoria 1939.
Exhibitions
'Piazzetta: A Tercentenary Exhibition of Drawings, Prints and Books', National Gallery
of Art, Washington, 1983-84, no. 34.
Literature
Howard Spensley, MSS. Book I, p. 22, no 585; G. Knox, *Piazzetta: A Tercentenary Exhibition
of Drawings, Prints and Books,* Washington, 1983, p. 104, no. 34.

There are three of Piazzetta's large-scale presentation drawings in the Melbourne print-
room, all dating from about 1742. Some of Piazzetta's most popular works were the so
called *têtes de caractère* – studies of people from everyday life. Although members of his
family are identifiable models for many of these, the drawings are not so much portraits of
actual individuals as generalized types, and when Cattini published a group of engravings
after these popular works, he called them *Images from Life.*

The Melbourne drawing shows Giacomo Giusti, the artist's son who was born in 1725.*
The same boy is model for many paintings and drawings, notably, *The Young Ensign,*
Dresden, *Giacomo feeding a Dog,* Chicago and *Boy with a Stick,* a drawing in the Ashmolean,
Oxford. In these drawings, one of Piazzetta's favourite devices is the arrested gesture or
glance, which reinforces the air of spontaneity and intimacy. Here, the boy's glance is
intercepted and, caught mid-expression, seems almost shifty. The execution of the drawing
has an immediacy and a certain rawness which is perhaps appropriate to the subject.

*G. Knox, loc. cit.

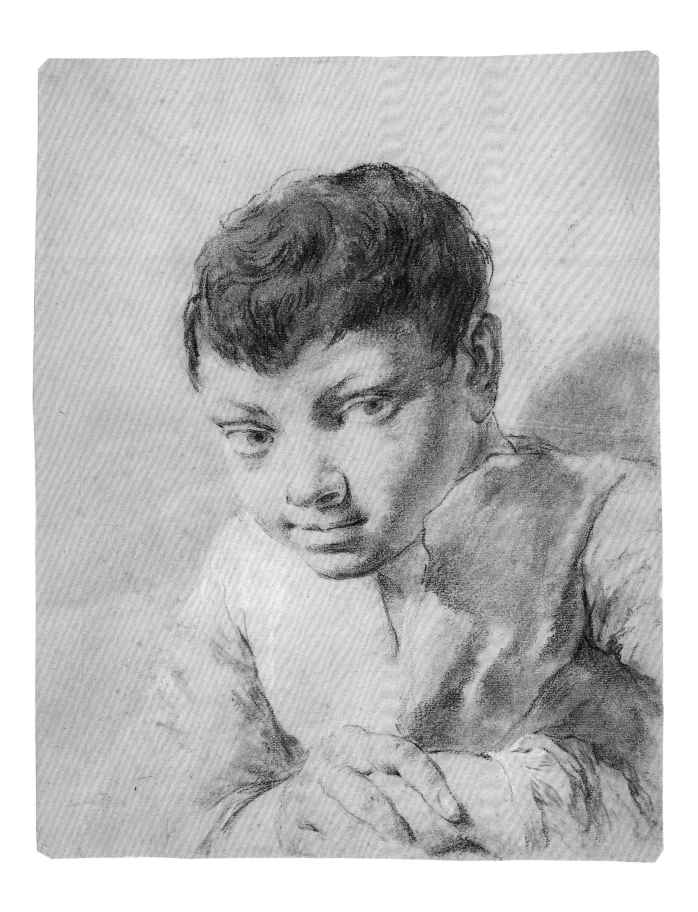

GIOVANNI BATTISTA PIAZZETTA
Italian 1683-1754

Diana
Black and white chalk
Signed and dated: Gio Batta Piazzetta/Fecit/Venezia 1743
39.5 x 31cm Inv. no. 239/4
Provenance
Henry Oppenheimer; Oppenheimer sale, Christie's, London, 10 July 1936, no. 138;
Felton Bequest, National Gallery of Victoria 1936.
Exhibitions
'Piazzetta: A Tercentenary Exhibition of Drawings, Prints and Books', National Gallery
of Art, Washington, 1983-84, no. 52.
Literature
K. T. Parker, *Henry Oppenheimer Collection*, 1936, no.138; A. Mariuz, *Opera Completa del Piazzetta*,
Milan, 1982, no. 52; G. Knox, *Piazzetta: A Tercentenary Exhibition of Drawings, Prints and Books*,
Washington, 1983, p. 103, no. 52.

In contrast to the head of Giacomo, *Diana* is a highly finished drawing of immense
technical skill and polish. The drawing is signed and dated which suggests that it was a
particularly important enterprise. The way the chalk is handled and the seductive silken
textures distinguish this drawing as much as its subject from the character heads, or images
from everyday life. George Knox suggests that it may well have been made in conscious
imitation of the style of Rosalba Carriera, his great Venetian contemporary who had evolved
a highly distinctive and personal drawing style.* In fact, Knox further suggests that this
drawing could have been intended as Piazzetta's homage to Rosalba Carriera.

*G. Knox, op. cit., p. 135.

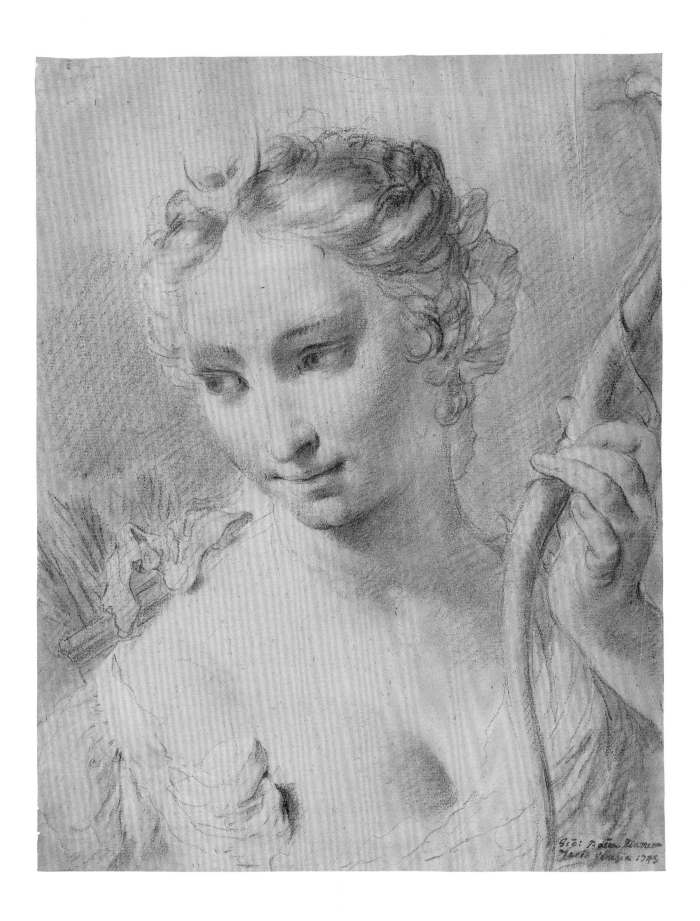

GIOVANNI BATTISTA TIEPOLO
Italian 1696-1770

Scene of a Baptism
Pen, bistre, wash
32.4 x 26.7cm Inv. no. 1019/5
Provenance
Lionel Lindsay; Felton Bequest, National Gallery of Victoria 1961.
Literature
H. Preston, 'A New Drawing by G. B. Tiepolo', *Annual Bulletin of the National Gallery of Victoria* IV, 1962, pp. 9-15, pl. 7; U. Hoff & M. Plant, *Painting Drawing Sculpture*, 1968, p. 4, fig. 9; J. Anderson, 'The subject of a drawing by G. B. Tiepolo reconsidered', *Art Bulletin of Victoria*, 1973-74, pp. 15-19, fig. 1.

The subject of this drawing, which shows a kneeling woman receiving a sacrament, has been a matter of speculation since it came into the collection in 1962. The scene is established as a baptism, but there have been various suggestions concerning the identity of the central figures.* In 1972, Dr Jaynie Anderson argued convincingly in favour of St Giustina and St Prosdocimus, a likely subject for a Venetian and one which had been treated by Campagnola.† St Prosdocimus, who came from Antioch, was sent by St Peter to Padua where he converted the ruler, his wife and their daughter Giustina as well as many local inhabitants. Giustina was to meet a martyr's death and is commemorated by a basilica in Padua. A drawing now in the Uffizi provides another piece of evidence of Tiepolo's interest in the subject of St Giustina, showing her martyrdom, watched by a group of orientals.

Stylistically, from the free manner in which pen and wash are handled, this drawing seems to date from about 1740. It is a highly charactertistic example of Tiepolo's use of pen and wash on crisp white paper. Although the ink has corroded the sheet in places, exaggerating some of the accents and contrasts, the sheer virtuosity and sparkle of this drawing is undiminished. Tiepolo usually chose a fine textured paper with only a moderately absorbent surface, allowing the fluent passage of the pen across the sheet and absolute control of the washes.‡ Marjorie Cohn claims that a quill pen rather than a reed was used.§ In these drawings the brown ink is sometimes bistre, sometimes iron gall; the latter initially a black ink turns brown with time and has a highly corrosive quality.

*H. Preston, op. cit.
†J. Anderson, op. cit.
‡M. Cohn, 'A Note on media and methods', *Tiepolo a Bicentenary exhibition 1770-1970*, Fogg Art Museum, 1970.
§ibid.

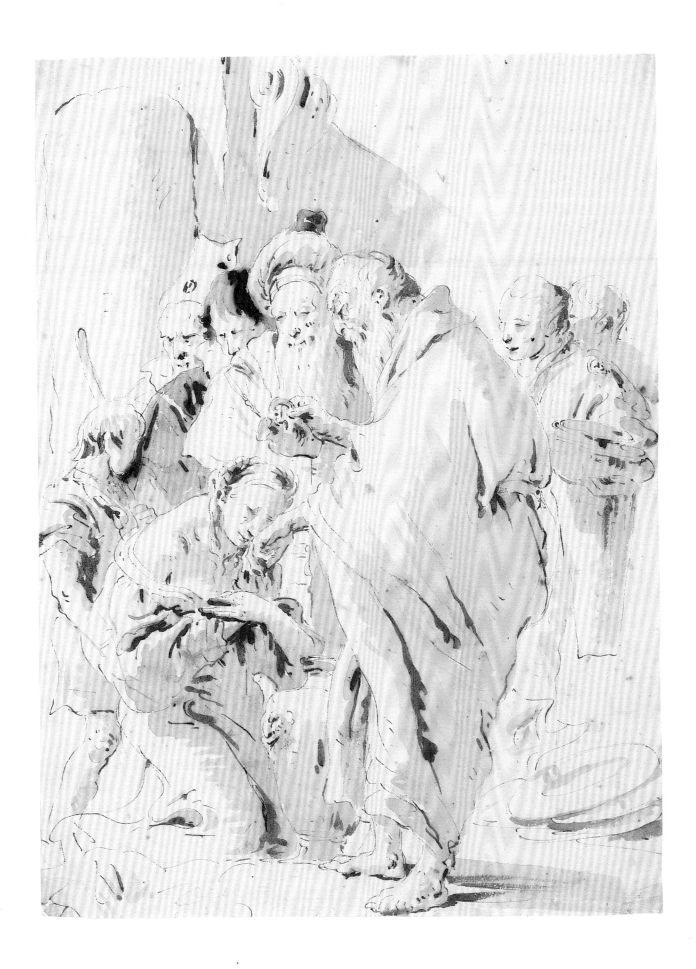

GIOVANNI BATTISTA TIEPOLO
Italian 1696-1770

Head of a Soldier
Black chalk heightened with white chalk on blue-grey paper
29.5 x 20.9cm Inv. no. 1895/4
Provenance
Prince Orloff, Paris, 1920; Colnaghi, National Gallery of Victoria 1948.
Exhibitions
'The Art of Drawing', 1964-65, no. 50; Hermitage, Leningrad, 1978-79, no. 14.
Literature
L. Froehlich-Bume, 'Notes on some works by Giovanni Battista Tiepolo', *Burlington Magazine* LXXII, February 1938, p. 82, pl.lc; K. M. Maison, *Themes and Variations,* London, 1960, pl.137; G. Knox, 'The Orloff Album of Tiepolo Drawings', *Burlington Magazine* CIII, June 1961, p. 269; H. Preston, 'A New Drawing by Giovanni Battista Tiepolo', *Annual Bulletin of the National Gallery of Victoria* IV, 1962; U. Hoff & M. Plant, *Painting Drawing Sculpture,* 1968, p. 8, fig. 10; S. Dean, Leningrad, 1978, p. 14, no. 14.

This drawing comes from the Orloff Album, a collection of ninety-six drawings by Giovanni Battista Tiepolo which were acquired by the Orloff family either in the 18th or early 19th century and remained with the family until 1920 when the album was sold and the drawings dispersed.*

The study was not identified until 1960, when K. M. Maison recognized it as the head of the soldier to the left of Alexander the Great in Veronese's painting *The Family of Darius before Alexander* which is now in the National Gallery, London.† In Tiepolo's lifetime, the painting was in the collection of the distinguished Venetian family, the Pisani, who had commissioned it in the 16th century. Tiepolo would have seen it in one of their palaces, but exactly when or where is uncertain. It is noted as being in Casa Pisani in 1739 but its precise location later in the century is not established. We know that Tiepolo's last commission in Italy was to decorate the Pisani family's ballroom at Villa Pisani on the Brenta at Strà in 1761-62. However, it is possible that this drawing was made earlier than that: Knox suggests a date of 1740-50 while Maison suggests 1753-62.‡ We also know from a letter, that Francesco Algarotti had considered commissioning the artist to make a copy of the Veronese painting about 1750; but the scheme did not proceed. It is nevertheless possible that this drawing could have been connected with the project.

Tiepolo usually chose a Venetian blue paper for his black and white chalk drawings. In the 15th century 'carta azzura', a paper coloured blue with cobalt or indigo which had been brought from Arabia, was commonly used in Venetian workshops. From about 1500 a blue paper was manufactured in Venice, known as 'Venezianer papier'.

*G. Knox, op. cit.
†K. M. Maison, op. cit.; L. Froehlich-Bume suggested a portrait of Charles V.
‡G. Knox, op. cit.

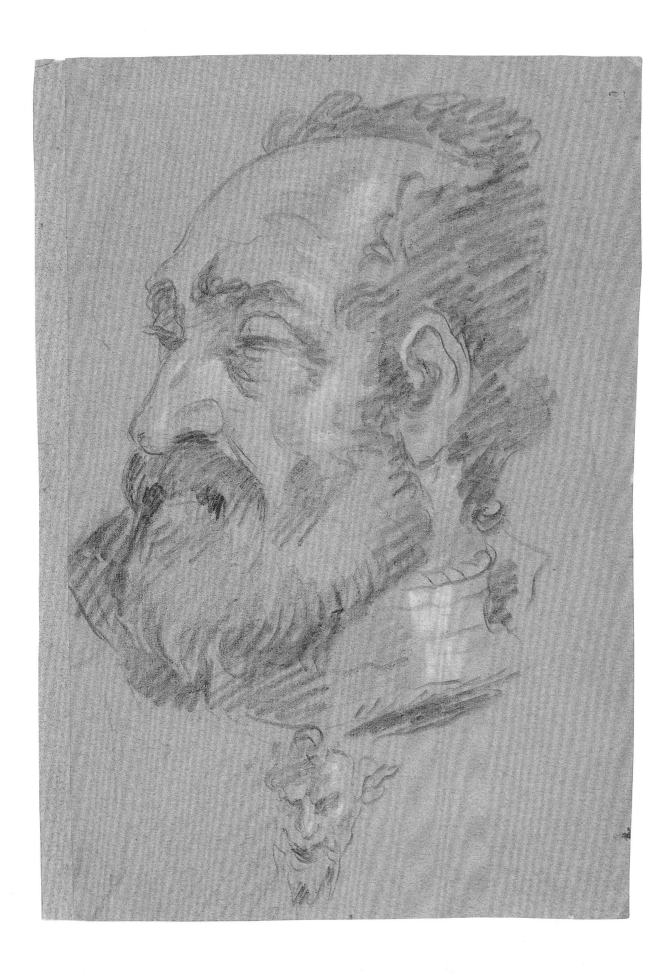

GIOVANNI ANTONIO CANAL, CANALETTO
Italian 1697-1768

Capriccio: A Tomb by a Lagoon
Pen and brown ink with grey wash
Inscribed l.l.: Anton Canal del [in later hand?]
29 x 40.5 cm Inv. no. 1278/3
Provenance
Unidentified collector's mark; R. C. Sticht; Felton Bequest, National Gallery
of Victoria 1923.
Exhibitions
Hermitage, Leningrad, 1978-79, no. 7.
Literature
W. G. Constable, *Canaletto: Giovanni Antonio Canal 1697-1768*, Oxford, 1962, vol. II,
p. 568; S. Dean, Leningrad, 1978, p. 12; no. 7.

This highly finished presentation drawing dates from the 1740s and shows all the brilliance
of Canaletto's late drawing style, which seems with age to increase in vivacity.* The rapid
pen notations are almost calligraphic in manner and are here used in subtle counterpoint
with multiple grey washes. As its title suggests, the scene is not an identifiable view, but a
work of the imagination, a fantasy.† Poetic in concept, it carries a hint of underlying
melancholy with the decaying antique tomb, a reminder of past splendours.

Canaletto painted at least three variations on this subject, in each case depicting a night
scene with the moon rising.‡ While it is conceivable that the Melbourne drawing could be
interpreted as an evening scene, though no moon is shown, the light seems too robust and
rather suggests angled late-afternoon sunlight. It seems likely that the drawing was made as
yet another variation on the theme, and is perhaps later than the paintings. The claim for its
independence from the paintings is reinforced by its degree of finish and by the double pen
border, both of which strongly suggest that it was intended to be seen as a presentation
drawing.

* W. G. Constable, loc. cit.
† A discussion on the use of the term *capriccio* can be found in W. L. Barcham, *The Imaginary Views of Antonio Canaletto*,
New York, 1977.
‡ W. G. Constable, op. cit., nos 486a & 486b, pl. 90, 486a. There is an engraving by Berardi of the subject showing a moonlit scene
and inscribed: 'Propizia e al pescator di lune il Lume'.

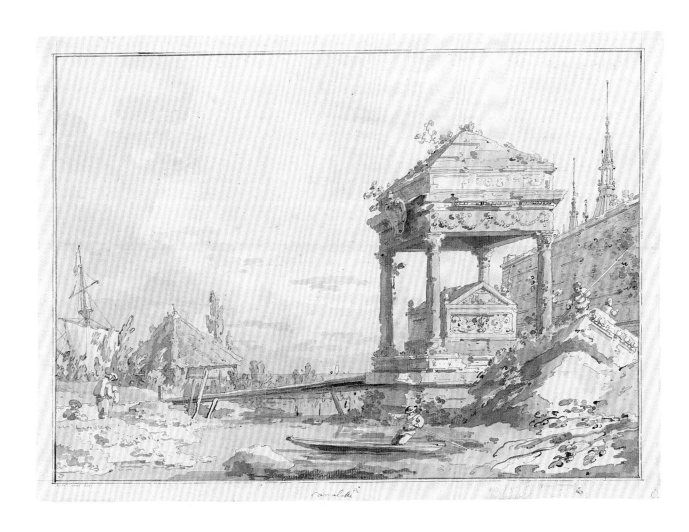

Canaletto

GIANDOMENICO TIEPOLO
Italian 1727-1804

Centaur carrying off a Female Faun
Pen and bistre wash
Inscribed l.r.: Domo. Tiepolo f.
18.9 x 27.3 cm Inv. no. 672/5
Provenance
Baron L.A. de Schwiter, Paris; Marquis de Biron; Yvonne ffrench, London; Felton
Bequest, National Gallery of Victoria 1960.
Exhibitions
'Old Master and Early English Drawings', Alpine Club Gallery, London, November 1959;
Hermitage, Leningrad, 1978-79, no. 16.
Literature
E. Sack, *G. B. und D. Tiepolo,* Hamburg, 1910; H. Preston, 'A New Drawing by Giovanni
Battista Tiepolo', *Annual Bulletin of the National Gallery of Victoria* IV, 1962, p. 12, pl. 10;
Jean Cailleux, 'Centaurs, fauns and satyrs among the Drawings of Domenico Tiepolo',
Burlington Magazine, June 1974, Supplement no. 52; S. Dean, Leningrad, 1978, p. 14, no. 16.

Among Giandomenico's allegorical drawings is a large group devoted to centaurs, nymphs,
fauns and satyrs. Some of these drawings relate directly to the mythological story of Nessus,
the centaur, who was entrusted by Herakles to carry Deianira across a river, but instead
abducted the girl, an act which led eventually to the death of all three protagonists. There
are many erotic and playful variations on the theme of centaurs cavorting with, or abducting
nymphs. Indeed, in the Melbourne drawing, it is not Deianira who is being borne away, but
a female faun with cloven hoof, and the mood is one of exhilaration rather than alarm as they
race through mountainous landscape.

In the Tiepolo family villa at Zianigo, near Padua, Giandomenico decorated a small
room with frescoes depicting centaurs, and known as Camerino dei Centauri.* Among the
frescoes are a number which relate closely to some of the centaur drawings but this alone is
insufficient evidence to confirm that these are studies for the centaur room.† It was noted by
Byam Shaw that these drawings are all similar in style and format which suggests a coherent
group on the same theme. However, even if they were made contemporaneously with the
decoration of the centaur room, they could represent a separate enterprise.‡ The drawings
are in pen, wash and bistre, a technique favoured by Giandomenico after his return to
Venice from Madrid. His early drawings are often difficult to distinguish from those of his
father, but the style of this drawing with its wiry line, mottled washes and scratchy
diagonal shading over the foreground wash, is distinctly his own.

*Camerino dei Centauri is dated 1791; the other room Camera dei Satiri, 1759.
†J. Cailleux, op.cit.
‡J. Byam Shaw, *The Drawings of Domenico Tiepolo,* London, 1962.

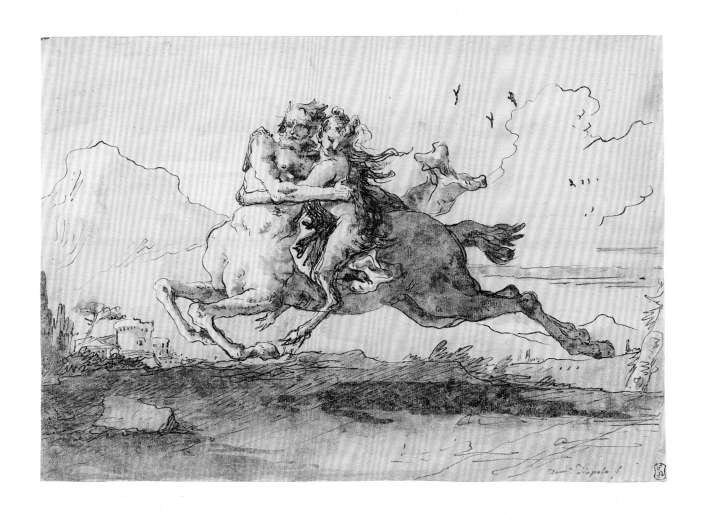

ALBRECHT DURER
German 1471-1528

The Virgin Crowned by an Angel

Pen and ink
Inscribed l.r.: AD in a monogram and dated 1520
13.7 x 9.5cm Inv. no. 360/4
Provenance
J. C. Ritter von Klinkosch, Vienna, 1899; J.P Heseltine, 1912;Henry Oppenheimer, Oppenheimer sale, 10 July 1936, no. 368; Felton Bequest, National Gallery of Victoria 1936.
Exhibitions
'The Art of Drawing', 1964-65, no. 89; 'Dürer and his Times', National Gallery of Victoria,Melbourne,1971, no. 59; Hermitage, Leningrad, 1978-79, no. 36.
Literature
J.P. Heseltine, *German Drawings,* no.10; C.Ephrussi, *Albrecht Dürer et ses Dessins,*Paris,1882, p. 191; C.Dodgson, *Masters of Engravings and Etching: Dürer,* London, 1926, p.129, no. 94; J.Meder, *Dürer Katalog,* Vienna, 1932, p. 85; no. 41; K.T. Parker, *Henry Oppenheimer Collection,*1936, no. 368; E.Panofsky, *Albrecht Dürer,* Princeton, 1947,vol. II, no. 683; U. Hoff, *The Art of Drawing,* 1964, no. 89; S.Dean, *Dürer and his Times,* Melbourne, 1971, no. 59; S.Dean, Leningrad, 1978, p. 20, no. 36.

In 1519 Dürer seems to have suffered a spiritual crisis which in part stemmed from the influence of the new teachings of the Reformation and from his admiration for Martin Luther. It affected every area of his life and in his art is reflected in the growing austerity and monumentality of his compositions.

This drawing, dated 1520, is for the engraving *Madonna and Child crowned by an Angel* (Bartsch 37). It shows a youthful Madonna who is placed frontally,filling the left and centre of the composition, while beyond her we glimpse a river landscape. The drawing was copied on to the copper plate by Dürer, the resulting engraving being printed in reverse of the drawn composition. There is only one slight compositional change in this transfer – that is to the small bird which perches like a clockwork toy but in the engraving spreads its wings as if to keep its precarious balance. The difference between drawing and engraving is nevertheless profound; it is one of mood rather than motif. While the drawing seems to be filled with light and air, the engraving is dark, brooding and full of foreboding. The Madonna sits against a thunderous sky, her face and skirt strangely and violently illuminated: the folds of her skirt, so lightly expressed in the drawing, are sculptural and massive, almost abstract forms. Perhaps the engraving more than the drawing sums up Dürer's mood and preoccupations in this period. The pen drawing nevertheless, with its infinite delicacy and certainty, reminds us of his supreme mastery as a draughtsman.

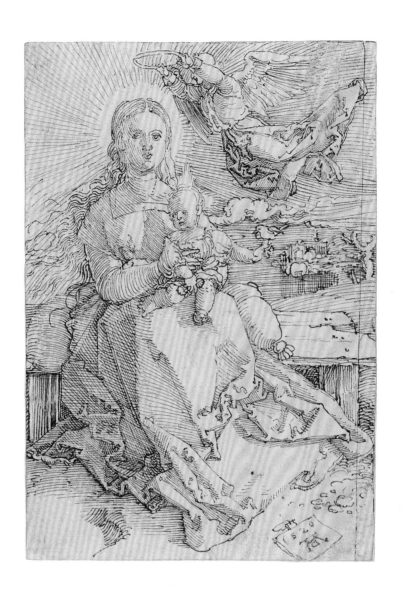

JACQUES DE GHEYN II
Flemish 1565-1629

Portrait of a Youth
Pen and brown ink
12.2 x 11cm Inv. no. 32/5
Provenance
C. van der Voordt Pieck 1937; H.J. Schretlen; Dr H.C. Valkeme Blouw 1954; Hoogendijk;
Colnaghi; Felton Bequest, National Gallery of Victoria 1958.
Exhibitions
'Old Master Drawings', Colnaghi's, London, 17 June-17 July 1958, no. 48; 'The Art of
Drawing', 1964-65, no. 54; Hermitage, Leningrad, 1978-79, no. 40.
Literature
P. & D. Colnaghi, *Exhibition of Old Master Drawings*, London, 1958, no. 48, pl. iii;
S. Higgins, *Distinction in Draughtsmanship*, Paris,1957; *Annual Bulletin of the National
Gallery of Victoria* I, 1959, fig. 5; U. Hoff, *The Art of Drawing*, 1964, no. 54; U. Hoff &
M. Plant, *Painting Drawing Sculpture*, 1968, p. 7, fig. 7; U. Hoff, *The National
Gallery of Victoria*,1973, pp. 88-89; S. Dean, Leningrad, 1978, p. 21, no. 40;
I.Q. van Regteren Altena, *Jacques de Gheyn: Three Generations*, The Hague, 1983,
pl. 372; no. 734.

Regteren Altena suggests that this drawing represents the artist's son, Jacques III who was
born in 1596 and would have been aged about twelve at the time of the portrait.[*] It is this
same youth who was later to be painted by Rembrandt in 1632.[†] Like his father he was
a painter and engraver, but also a collector and a traveller, visiting both England and
Sweden.[‡] He no longer worked as an artist after his father died and was appointed
a Canon at St Mary's, Utrecht in 1634 where he remained until his death in 1641.

In this sensitive study of the boy's head, we see that de Gheyn II's drawing comes from
a tradition of engraving, apparent in his use of dots and in the delicate hatching which
models the face. We also see his indebtedness to his master, Goltzius, and through him to
Dürer. However, there are elements here which are quite new and anticipate the work of
later 17th century masters.[§]

[*] I.Q. van Regteren Altena, op.cit.
[†] Dulwich College, London, portrait dated 1632; A. Bredius H.Gerson, no. 162
[‡] The painting *The Two Philosophers* by Rembrandt, now in the Gallery, was in the collection of Jacques de Gheyn III.
[§] Ursula Hoff refers to him as forerunner of Rembrandt; U. Hoff, 1964, no. 54; Regteren Altena, no. 734.

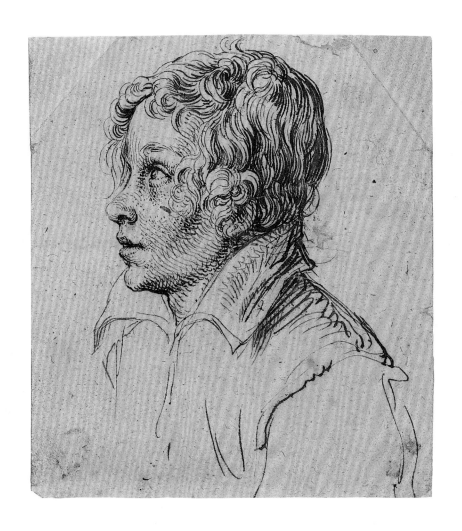

REMBRANDT HARMENSZ VAN RIJN
Dutch 1606-69

Sheet of Studies
Verso: Study of a Girl Sleeping and head of an oriental in profile
Pen and bistre
Inscribed in a later hand: Rembrand f
20.9 x 13.7 cm Inv. no. 356/4
Provenance
Ploos van Amstel 1810; W. W. Knighton; J. P. Heseltine 1913; Henry Oppenheimer;
Oppenheimer sale, Christie's, London, 10 July 1936, no. 289; Felton Bequest,
National Gallery of Victoria 1936.
Exhibitions
Royal Academy, London, 1899, no. 140; 'Dutch Exhibition', Burlington House, London,
1929, no. 582; Hermitage, Leningrad, 1978-79, no. 43.
Literature
C. Hofsted de Groot, *Die Handzeichnungen Rembrandts,* Haarlem, 1906, no. 1022; *Dutch Exhibition,*
London, 1929, no. 582; K. T. Parker, *Henry Oppenheimer Collection,* 1936, no. 289; O. Benesch,
The Drawings of Rembrandt, London, 1954, vol. II, no. 194; S. Dean, Leningrad, 1978,
p. 22, no. 43.

Otto Benesch suggests that this sheet of sketches comes from Rembrandt's early days
in Amsterdam, and dates from about 1632. He points out its resemblance to the Leyden
drawings, noting the study on the verso of an oriental which is comparable with another
work of that date.* We know that during this period Rembrandt made numerous sketches
from everyday life, of street scenes, of the family indoors, of people looking out of windows,
gesturing, or sitting alone. All of these drawings were made as observations, not necessarily
as studies for particular works, but also as a constant source of reference. In the two studies
of a woman with her hands folded on her lap, and a woman holding a baby, Rembrandt
seems in a brief calligraphic gesture to encapsulate the living moment.

*O. Benesch, op. cit., no. 194.

REMBRANDT HARMENSZ VAN RIJN
Dutch 1606-69

Old Man in a Turban
Pen and gall-nut ink
Inscribed in a later hand: Rembrandt f. 1656
17.3 x 13.5 cm Inv. no. 357/4
Provenance
Benjamin West 1820; Thomas Lawrence 1830; William Esdaile 1840; C. S. Bale 1881;
J. P. Heseltine 1913; Henry Oppenheimer 1935; Oppenheimer sale, Christie's, London,
10 July 1936, no. 292; Felton Bequest, National Gallery of Victoria 1936.
Exhibitions
'Dutch Exhibition', Burlington House, London, 1929, no. 581; 'Rembrandt', Amsterdam,
Rotterdam, 1956, no. 86; 'The Art of Drawing', 1964-65, no. 21; 'Rembrandt 1606-1669',
National Gallery of Victoria, Melbourne, 1969.
Literature
C. Hofsted de Groot, *Die Handzeichnungen Rembrandts*, Haarlem, 1906, no. 986; *Dutch Exhibition*,
London, 1929, no. 581; K. T. Parker, *Henry Oppenheimer Collection*, 1936, no. 292; O. Benesch,
The Drawings of Rembrandt, London, 1954, vol. I, no. 157; U. Hoff, *The Art of Drawing*, 1964,
no. 21; U. Hoff & M. Plant, *Painting Drawing Sculpture*, 1968, p. 7, fig. 6; U. Hoff, *Rembrandt
1606-1669*, Melbourne, 1969, p. 4; U. Hoff, *The National Gallery of Victoria*, 1973, p. 89.

This study is one of several drawings Rembrandt made for one of the elders who, in the old
testament story, spies upon the naked Susanna while she is bathing. Otto Benesch suggests
that the drawing was made for the 1637 painting of that subject which is now in the
Mauritshuis in the Hague. It was not used for that picture, but ten years later when
Rembrandt returned to the subject for a painting which is now in Berlin, he must have
looked back to this earlier drawing of the rapacious old man whose voyeurism and lechery
seem to distort his every feature. In the Berlin painting he is the elder who appears directly
behind Susanna, and reaches out to remove her robe. Although there have been some
changes, this figure is clearly derived from the present study.

*The gall-nut ink, which Rembrandt used, has violently corrosive qualities and has here as in many instances, eaten into the paper
and darkened.

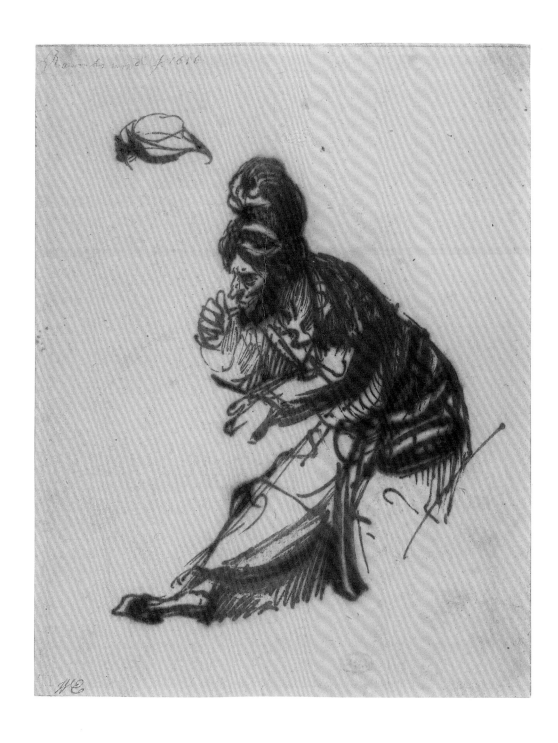

ARENT DE GELDER
Dutch 1645-1727

The Reconciliation of David and Absalom
Pen, brush and bistre, indian ink with green and pale-blue washes
19.2 x 30.5cm Inv. no. 354/4
Provenance
Albertina (Archduke Friedrich), Vienna; Henry Oppenheimer; H. Oppenheimer
sale, Christies, London, 10 July 1936, no. 247; Felton Bequest, National Gallery of
Victoria 1936.
Exhibitions
'Dutch Exhibition', Burlington House, London, 1929, 'The Art of Drawing', 1964-65, no. 8;
Hermitage, Leningrad, 1978-79, no. 41.
Literature
Dutch Exhibition, London, 1929, no. 675; J. Byam Shaw, 'Arent de Gelder',
Old Master Drawings IV, pp. 10-13, pl. 15; C. Hofsted de Groot, *Repertorium fur
Kunstwissenschaft* I, Haarlem, 1929, p. 144; K. T. Parker, *Henry Oppenheimer Collection,*
1936; U.Hoff, *The Art of Drawing,* 1964, no. 8; S. Dean, Leningrad, 1978, p. 21; no. 41.

When this study was in the Oppenheimer collection, James Byam Shaw described it as
unequivocally the finest de Gelder drawing known to him.* In firmly supporting its old
attribution, he squashed the then current suggestion that it was by Constantyn à Renesse.
In discussing the features which convinced him of its authorship, he noted the distinctive
and exaggerated gestures of the hands, the broad brushwork, and the delight in exotic
costume, in particular the turban worn by the figure on the right.

De Gelder's debt to Rembrandt is clear, more particularly in this drawing because it
echoes, if only faintly, a painting by Rembrandt of 1642, now in the Hermitage Museum,
Leningrad, which is called 'David and Jonathan' or 'David and Absalom.' In the painting
we see two exotically-robed figures in an architectural setting which bears a passing
resemblance to this drawing. We do not know if de Gelder ever saw this painting. The
precise subject of his drawing remains a matter of conjecture; in the Oppenheimer sale
it was called 'David and Jonathan', subsequently it has been known as *The Reconciliation
of David and Absalom.*

*J. Byam Shaw, op.cit.

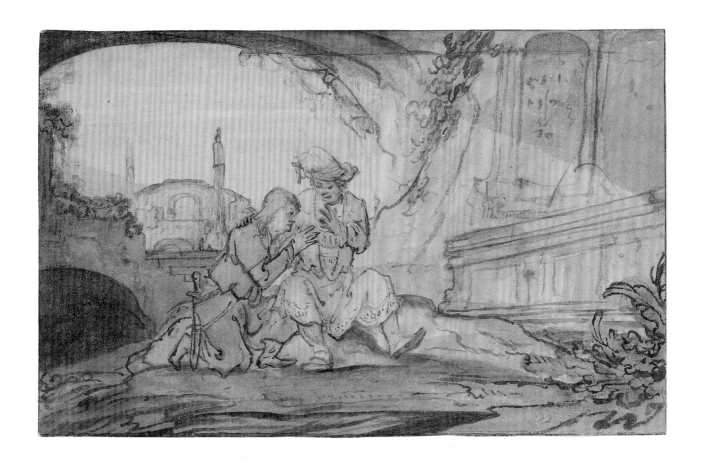

THOMAS GAINSBOROUGH
English 1727-88

Upland Landscape with Market Cart, Cottages and Figures
Grey wash heightened with white
Inscribed on verso in an old hand: Drawn by Gainsborough 1778, 1833 WE 56 +
Dr Monro's sale
26.8 x 34.6cm Inv. no. 2228/4
Provenance
Dr Thomas Monro; Monro sale, Christie's, London, 1833, no. 158; Thane; William
Esdaile; Esdaile sale, Christie's, London, 1838, no. 675; Rodd; Spink; Sir Thomas
Barlow 1936; presented by Sir Thomas Barlow to the National Gallery of Victoria 1950.
Exhibitions
'The Art of Drawing', 1964-65, no. 68B; Hermitage, Leningrad, 1978-79, no. 55.
Literature
M. Woodall, *Gainsborough's Landscape Drawings*, London, 1939, no. 301; J. Hayes,
The Drawings of Thomas Gainsborough, London, 1970, no. 464; U. Hoff, *The Art of Drawing*,
1964, no. 68B; U. Hoff & M. Plant, *Painting Drawing Sculpture*, 1968, p. 98; U. Hoff,
The National Gallery of Victoria, 1973, p. 96; S. Dean, Leningrad, 1978, p. 25, no. 55.

Gainsborough's landscape drawings were frequently made in his leisure time in the
evenings, seemingly mostly for his own pleasure, sometimes to be kept, sometimes as gifts
for friends. He was a prolific draughtsman and though he did make studies for paintings
this was not their primary function. From his boyhood in Suffolk and through much of his
life, he sketched outdoors, but none of the landscape drawings is made in this way, and
whether they represent a rustic English scene or an Italianate landscape, they are always
'inventions' – works of his imagination.

 When Gainsborough returned to London from Bath in the 1770s, the style of his
landscape drawing underwent a change. He was an indefatigable experimenter in all media
– William Jackson wrote in 1798, 'No man ever possessed methods so various in producing
effects, and all excellent'. His drawings seem at this period to be rapid notations in black
and white chalk which is used in combination with grey and grey-black washes.

 Upland Landscape with Market Cart, Cottages and Figures, dated 1778, demonstrates fully this
new style with its summary lines indicating horse, cart and foliage, and subtle dashing grey
washes with white highlights which describe the terrain. This drawing passed into the notable
collection of Dr Thomas Monro, a collection which he regularly allowed a younger
generation of painters to study, among them Turner and Girtin.

THOMAS GAINSBOROUGH
English 1727-88

Mountain Landscape with Classical Buildings, Shepherds and Sheep
Black chalk and stump and white chalk
Inscribed on the old mount: original chalk drawing by Gainsboro given by him to my
Father Rich[d] French after the style of Gaspar Poussin
28.1 x 37.3 cm Inv. no. 2356/4
Provenance
Presented by the artist to Richard French; Guy Bellingham Smith; Colnaghi; J. Leslie
Wright 1936; Howard Bliss; Leicester Galleries; Felton Bequest, National Gallery of
Victoria 1951.
Exhibitions
'Drawings by Thomas Gainsborough', Oxford Arts Club, 1935, no. 2; 'Gainsborough',
Sassoon, 1936, no. 45; 'From Gainsborough to Hitchens', The Leicester Galleries, January
1950; 'The Art of Drawing', 1964-65, no. 68A; Hermitage, Leningrad, 1978-79, no. 54.
Literature
M. Woodall, *Gainsborough's Landscape Drawings*, London, 1939, no. 390, pp. 23, 70-1,
pl .92; U. Hoff,' Note', *The Quarterly Bulletin of the National Gallery of Victoria* V, 4, 1951;
J. Hayes, 'Gainsborough and the Gaspardesque', *The Burlington Magazine*, May 1970,
p. 311; J. Hayes, *The Drawings of Thomas Gainsborough*, London, 1970, no. 634; U. Hoff,
The Art of Drawing, 1964, no. 68A; S. Dean, Leningrad, 1978, p. 25, no. 54.

This landscape with an Italianate building to the left, a wild mountain road, a gorge and
distant mountains is clearly no English scene. It is in fact made up of elements from 17th
century European landscape paintings, in particular those of the French painter, Gaspard
Dughet, known as Gaspard Poussin 1625-75, who lived in Rome. Gaspard whose work
combined elements of both Nicholas Poussin's classicism and of Claudian romanticism
was a strong influence on English 18th century ideas on landscape and concepts of the
picturesque.

We know that Gainsborough was already interested in Gaspard's works as early as the
1760s, but this influence becomes marked in the 1780s. Hoppner records that at this time
Gainsborough 'made chalk studies from the works of more learned painters of landscape,
especially Gaspard Poussin.'* This is confirmed by an inscription on the old mount:
'Original chalk drawing by Gainsboro given by him to my Father Rich[d] French after the
style of Gaspar Poussin'. Hayes dates this drawing from the mid to the late 1780s.†

*Hoppner, *Quarterly Review*, 1809.
†F. Hayes, London, 1970.

WILLIAM BLAKE
English 1757-1827

Antaeus setting down Dante and Virgil in the Last Circle of Hell
Pen and watercolour
Watermark: WE
52.6 x 37.4cm Inv. no. 1012/3
Provenance
John Linnell; Christie's sale, London, 1918; Felton Bequest, National Gallery of Victoria 1920.*
Exhibitions
Royal Academy, 1893, no. 18; 'The Works of William Blake', Tate Gallery, 1913-14, no. 41:
Manchester, no. 48, Nottingham. no. 42, Edinburgh, no. 67; 'William Blake', Melbourne,
1957-58, no. 66; 'William Blake', Tate Gallery, 1978, no. 328; 'The Poetical Circle',
Australia, 1979, no. 60; 'Blake e Dante', Torre de' Passeri, Pescara, 1983, no. 66.
Literature
M. Rossetti, *Annotated Catalogue of Blake's Pictures and Drawings,* London, 1863, p. 220;
1880, p.232; A. Blunt, 'Blake's Pictorial Imagination', *Warburg Journal* VI, 1943, p. 211;
A.S. Roe, *Illustrations to the Divine Comedy,* Princeton, 1953, pp. 124-5, no. 63; A. Blunt,
The Art of William Blake, London, 1959, p. 90; U. Hoff, *The Melbourne Dante Illustrations
by William Blake,* Melbourne, 1961, p. 29, no. 25; U. Hoff & M. Plant, *Painting Drawing
Sculpture,* 1968, p. 104; U. Hoff, *National Gallery of Victoria,* 1973, p. 91; M. Butlin, *William
Blake,* London, 1978, no. 328; M. Klonsky, *Blake's Dante,* New York, 1980, p. 90; M. Butlin,
The Prints and Drawings of William Blake, Yale, 1981, p. 575, no. 812-63; C. Gizzi, *Blake e
Dante,* Pescara, 1983, p. 144, no. 66.

H. F. Cary's translation of Dante's *Divine Comedy,* published in 1814, was the first complete
translation into English of that classic work. Only ten years later, John Linnell, Blake's
patron and friend commissioned the artist to make a series of drawings illustrating
The Divine Comedy. This project occupied the last three years of his life and on his death in
1827, the 102 watercolour drawings were in various states of finish, while only seven of the
intended engravings were completed.

One of Blake's most dramatic and famous images for this enterprise is the drawing of the
giant Antaeus, who helps Virgil and Dante descend to the ninth and lowest circle of Hell.
He is shown in a curiously angled pose, releasing Dante from his grasp, as the poet joins
Virgil on the lower ledge. Antaeus's massive scale is described by Dante in the text as
comparable to the great leaning tower of Bologna, the Carisenda, encircled by clouds.

> *...As appears*
> *The tower of Carisenda, from beneath*
> *Where it doth lean, if chance a passing cloud*
> *So sail across, that opposite it hangs,*
> *Such then Antaeus seem'd as at mine ease*
> *I mark'd him stooping. I were fain at times*
> *T' have pass'd another way. Yet in th' abyss*
> *That Lucifer with Judas low ingulfs,*
> *Lightly he plac'd us; nor there leaning stay'd,*
> *But rose as in bark the stately mast.* †

The source of Blake's leaning figure has been identified by Franz Philipp as an image from
a work by the mannerist painter, Pellegrino Tibaldi,‡ and it also reveals Blake's enduring
admiration for Michelangelo. Blake's approach to Dante's text is both literary and visionary.
The cloud which encircles the Carisenda in the text encloses Antaeus in the painting but as
Arthur Roe has indicated it also symbolizes the barrier between the material world of man's
physical nature and the internal world of the imagination, represented by Antaeus and the
poets. Blake is himself thus frequently commentator on the text.

Antaeus is one of the most highly finished of the series of drawings, and watercolour is
used in a characteristically highly-wrought manner with much re-working and stippling,
producing intense and luminous colour.

*The Blake drawings were acquired in 1918 by the Felton Bequest but officially handed over to the Gallery in 1920.
†From Cary's translation, 'Inferno', Canto XXXI 127-36. ‡F. Philipp, U. Hoff & M. Plant, loc. cit.

HELL Canto 31

WILLIAM BLAKE
English 1757-1827

St Peter, Beatrice, Dante and St James
Pen and watercolour over pencil
Watermark: WE
37.1 x 52.7cm Inv. no. 1022/3
Provenance
John Linnell; Christie's sale, London, 1918; Felton Bequest, National Gallery
of Victoria 1920.
Exhibitions
'William Blake', Melbourne, 1957-58, no. 76.
Literature
M. Rossetti, *Annotated Catalogue of Blake's Pictures and Drawings,* London, 1863, p. 222;
1880, p. 234; A. S. Roe, *Illustrations to the Divine Comedy,* Princeton,1953, pp. 183-4, no.
95; U. Hoff, *The Melbourne Dante Illustrations by William Blake,* Melbourne, 1961, p. 39,
pl.35; J. Beer, *Blake's Visionary Universe,* Manchester,1969, p. 279; M. Klonsky, *Blake's
Dante,* New York, 1980, p. 122.

In this drawing for the third part of *The Divine Comedy,* 'Paradiso', Dante, having been
questioned by St Peter on Faith, is interrogated by St James on Hope. The two saints
approach one another like meteors enveloped in flame, while Dante and Beatrice hover
below them. St Peter carries the Key, symbolizing the Kingdom of God on Earth in his left
hand, while with his right he makes the sign of the benediction. The latter was an addition
of Blake's which does not appear in Dante's description of their meeting:

> *Next from the squadron, whence had issued forth*
> *The first fruit of Christ's vicars on the earth,*
> *Towards us moved a light, at view whereof*
> *My Lady, full of gladness, spake to me:*
> *'Lo! Lo! behold the peer of mickle might,*
> *That makes Galicia throng'd with visitants'.*
> *As when the ring-dove by his mate alights;*
> *In circles, each about the other wheels,*
> *And, murmuring, cooes his fondness: thus saw I*
> *One, of the other great and glorious prince,*
> *With kindly greeting, hail'd; extolling, both,*
> *Their heavenly banqueting.**

The drawing reveals Blake's own complex mythology which is interwoven with Dante's text.
Arthur Roe points out that St Peter as Faith 'is concerned with the operation of grace in a
fallen world' while St James, Hope is concerned with the expectation of salvation.†

The drawing is unfinished but the colours and design are almost fully developed. The
colours for the 'Paradiso' illustrations are characteristically high key and more transparent
than for the two preceding sections 'Inferno' and 'Purgatorio'. The design for this meeting
of the two saints 'so burning bright I could not look upon them', with its diagonal rays of
light extending to the edge of the sheet and vibrant colour has the intensity and luminosity
of a vision.

*'Paradiso', Canto XXV 15-26 – Cary's translation.
†Roe also points out that Hope as the 'unfallen emotional life' corresponds with Blake's 'Luvah'; Roe, op. cit., p. 184.

WILLIAM HOLMAN HUNT
English 1827-1910

The Lady of Shalott
Black chalk, pen and ink
23.5 x 14.2 cm Inv. no. 1133/3
Provenance
Given by Hunt to Coventry Patmore or his wife; Felton Bequest, National Gallery
of Victoria 1921.
Exhibitions
'Pre-Raphaelite Art', State Art Galleries of Australia, 1962, no. 33; Walker Art Gallery,
1969, no. 119; 'Praraffaeliten', Baden-Baden and Frankfurt, 1973-74, no. 33; 'The
Pre-Raphaelites and their Circle', National Gallery of Victoria, Melbourne, 1978, no. 23;
Hermitage, Leningrad, 1978-79, no. 62.
Literature
G. S. Layard, *Tennyson and his Pre-Raphaelite Illustrators*, London, 1894, p. 39; W. M.
Rossetti, *Pre-Raphaelite Diaries and Letters*, London, 1900, p. 279, entry for 24 October
1850; W. Holman Hunt, *Pre-Raphaelitism and the Pre-Raphaelite Brotherhood*, London, 1905,
vol. I, p. 211; 1913, vol. II, pp. 73, 75; D. Thomas, 'Pre-Raphaelite Works in the National
Gallery of Victoria', *Annual Bulletin of the National Gallery of Victoria* II, 1960, pp. 21-27, fig.
25; S. J. Wagstaff Jr, 'Some Notes on Holman Hunt and The Lady of Shalott', *Wadsworth
Atheneum Bulletin*, Summer, 1962, p. 6, fig. 4; M. Bennett, *William Holman Hunt*, Liverpool,
1969, no. 119; *Praraffaeliten*, Baden-Baden, 1973, no. 33, p. 98, no. 49; A. Dixon,
S. Dean & I. Zdanowicz, *The Pre-Raphaelites and their Circle*, Melbourne, 1978, p. 43, no.
23; S. Dean, Leningrad, 1978, p. 26, no. 62; Brown University, *Ladies of Shalott, A Victorian
Masterpiece in its context*, Providence, 1985, p. 63.

This illustration of Tennyson's poem, *The Lady of Shalott*, is the earliest of Holman Hunt's
versions of the subject and dates from 1850. It illustrates the catastrophic moment when the
curse strikes. The Lady of Shalott, who is incarcerated in her tower must weave a tapestry
recording life in Camelot but is forbidden to look on the outside world except through a
mirror. Seeing Sir Lancelot ride by, she turns to look at him and fatally:

> *Out flew the web and floated wide*
> *The mirror cracked from side to side*
> *'The curse is come upon me' cried*
> *The lady of Shalott.*

Unlike subsequent versions of the subject, it is a restrained representation which stays true
to the poem. By constrast the design which Hunt made for 'Moxon's Tennyson' in 1857,
enraged the poet, who thought that her hair looked as if it had been blown by a tornado,
causing him to remark testily, 'an illustrator ought never to add anything to what he finds
in the text.'* This drawing more faithfully records the snapping of the threads which swirl
about her like a spider's web – another detail which later got out of hand and annoyed
the poet. The cracked central mirror reflects Sir Lancelot, the unwitting cause of the
catastrophe. In the small mirrors which surround it, Hunt traces the narrative of the poem
to its conclusion in small vignettes. It has been suggested that the large mirror with its small
satellites was inspired by the mirror in van Eyck's painting *The Marriage of the Arnolfini*
which had been acquired by the National Gallery, London, only a few years before.†

'The Lady of Shalott' was a subject which occupied Hunt for half a century; there are a
number of studies as well as the wood engraving and two paintings, the last finished in 1905.

*Holman Hunt, 1913 edn, vol. II, p. 96.
†S. J. Wagstaff Jr, op. cit.

81

SIR EDWARD BURNE-JONES
English 1833-98

Ladies and Death
Pen and ink over pencil laid down on thin card
Inscribed verso l.l.: Designed and drawn by E. Burne-Jones
The property of Geo P. Boyce Aug. 4, 1860; l.c.: Ladies and Death;
l.r.: George Price Boyce
14.4 x 45 cm Inv. no. 41/2
Provenance
Bought from the artist by G. P. Boyce; Boyce sale, Christie's, London, 1 July 1897,
no. 142; National Gallery of Victoria 1898.
Exhibitions
'Pre-Raphaelite Art', State Art Galleries of Australia, 1962, no. 12; 'Burne-Jones', Arts
Council of Great Britain, 1975, no. 21; 'The Pre-Raphaelites and their Circle', National
Gallery of Victoria, Melbourne, 1978, no. 11; Hermitage, Leningrad, 1978-79, no. 45.
Literature
M. Bell, *Sir Edward Burne-Jones. A Record and Review*, 2nd edn, London, 1893, p. 28;
D. Thomas, 'Pre-Raphaelite Works in the collection of the National Gallery of Victoria',
Annual Bulletin of the National Gallery of Victoria II, 1960, pp. 21-27, fig. 27; M. Wilson,
V.&A. Yearbook III, 1972, p. 140; J. Christian, 'Burne-Jones Illustrations to the Story
of Buondelmonte', *Master Drawings* II, 3, 1973, pp. 279-88; A. Dixon, S. Dean & I.
Zdanowicz, *The Pre-Raphaelites and their Circle*, Melbourne, 1978, p. 31, no. 11; S. Dean,
Leningrad, 1978, p. 23, no. 45.

On his first visit to Italy in 1859, Burne-Jones went to Pisa where he saw the fresco *The
Triumph of Death* in Campo Santo. This was to inspire the drawing *Ladies and Death* which
he made on his return to England.* In fresco and drawing, the figure of death appears to
the unsuspecting company in a garden.

During the 1850s, Burne-Jones had devoted much of his time to making elaborate
pen drawings rather than to painting. This change of medium was partly a result of his
indifferent health, but also he had been attracted to Rossetti's pen and ink drawings of the
period. Burne-Jones's own highly elaborate and painstaking technique seen in this drawing,
where tones are built through laborious hatching and dots and flicks, in much the manner
of an engraver, seems to have been the result of Ruskin's book *The Elements of Drawing*
which had been published in 1857. Ruskin also advocated the study of Dürer's engravings.
This influence can be detected particularly in his treatment of the central column, which
separates the ladies from the shrouded figure of death and the sunflower-entwined graves.

* Burne-Jones used the design for *Ladies and Death* a second time in 1860, when he decorated the panel of a piano which had been given as a wedding present. It is now in the Victoria and Albert Museum.

CLAUDE GELLEE, CLAUDE LORRAIN
French 1600-82

Landscape with Jacob, Rachel and Leah at the Well
Chalk, pen and brown ink, brown wash laid down on card
Inscribed on verso, u.l., decipherable as: 'Vostr tr aff˟ Serviteur/Claudio
Gillee/Dit Lorrain.'
Inscribed on verso of mounting paper by J. Richardson (1665-1745) transcribing Claude's original wording:
'Monseigneur. Jestoy attendant de vous faire quelq. dessein comme je vous a vois signifie mais il Sig.ʳᵉ Dewael ma
ordonne un atre Tableau de la grandeur de ces deux q. vous avez receu, c'est pourquoy je vous envoye ces present
designe pour le pouvoir accompagner, attendant un mot de response et la mesure pour faire faire la toille, je suis
de coeur pour sevire a qui je suis*/Vostr tr aff˟ Serviteur/Claudio Gillee/Dit le Lorrain/a Rome ce 28 Mars 1665.
This is on the back of the Drawing, only some part was cut off, being on the paper w. ch was beyond the Line of
the Landsc. So farr as to the asterisk is of some other, the rest is of Claude's own hand; all Spelt as here.'
16.1 x 22 cm Inv. no. 3083/4
Provenance
J. Richardson Snr (1665-1745); J. Richardson Jr (1694-1771); Bishop Buxton until 1953;
Colnaghi 1953; Felton Bequest, National Gallery of Victoria 1954.
Exhibitions
'McDonnell Memorial Exhibition', National Gallery of Victoria, Melbourne, 1964, no.
4; 'The Art of Drawing', 1964-65, no. 64; Hermitage, Leningrad, 1978-79, no. 26.
Literature
P.&D. Colnaghi, *Old Master Drawings*, London, 1953, no. 43, pl.8; U. Hoff, 'The Landscape
with a Group of Trees', *The Quarterly Bulletin of the National Gallery of Victoria* IX, 3, 1955,
p. 5; M.Roethlisberger, *Claude Lorrain, The Paintings: Critical Catalogue*, New Haven, 1961,
p. 400, fig. 273; *McDonnell Memorial Exhibition*, Melbourne, 1964, no. 4; M. Roethlisberger,
Claude Lorrain, The Drawings, Berkeley and Los Angeles, 1968, pp. 357-8, no. 963;
S. Dean, Leningrad, 1978, p. 17, no. 26.

In March 1665, Claude sent two drawings to Henri van Halmale, a patron who lived in
Antwerp. Halmale already owned two Claude paintings and had ordered a third through
his Rome agent, de Wael. The two drawings were sent to him as models from which he
could choose the composition for the new work. All this we know from the inscription on
the verso of the Melbourne drawing – one of the works in question: the second drawing,
which in fact Halmale chose, is in the National Gallery of South Africa.* The painting,
completed in 1666, is now in the Hermitage Museum, Leningrad. The inscription offers
a rare insight into Claude's relationship with his patrons and is one of the few recorded
instances of a direct communication between artist and patron. Roethlisberger has
translated the inscription, 'Sir, I was going to make you some drawings as I had told you,
but Mr de Wael (Halmale's agent in Rome) ordered on your behalf another painting of the
size of those two which you have received. I therefore send you the present drawings for a
projected pendant to the two paintings awaiting an answer and the exact size so that I can
order the canvas. Yours…'†

 Altogether Claude made five preparatory drawings for this composition, four of them
basically alike, though the Melbourne drawing transposes the position of the bridge to the
right of the composition. Characteristically, the foreground has been drawn in pen while
the middle ground and distance are drawn in chalk. Although this was intended to be
essentially a model and not a presentation drawing, it is a detailed and quite highly
finished work.

*M. Roethlisberger, 1968, no. 962.
†ibid., p. 358.

CLAUDE GELLEE, CLAUDE LORRAIN
French 1600-82

A Wooded Landscape
Pen and brown ink, black chalk with white heightening on pink tinted paper
19.4 x 28 cm Inv. no. P46/1981
Provenance
Livio Odescalchi inventory 1713; Odescalchi family until 1960; Georges Wildenstein; Norton
Simon 1968; Thomas Agnew; Felton Bequest, National Gallery of Victoria 1981.
Exhibitions
Palace of the Legion of Honor, San Francisco, 1970; 'Wildenstein Album'; Los Angeles
County Museum, Los Angeles, 1971; 'The Claude Lorrain Album in the Norton Simon
Inc. Museum of Art', Los Angeles, 1971, no. 33.
Literature
M. Roethlisberger, *Claude Lorrain, The Wildenstein Album,* Paris, 1962, p. 16, no. 9;
M. Roethlisberger, *Claude Lorrain: The Drawings,* Berkeley and Los Angeles, 1968,
p. 327, no. 877; M. Roethlisberger, *The Claude Lorrain Album in the Norton Simon Inc.
Museum of Art,* Los Angeles, 1971, p. 24, no. 33; I. Zdanowicz, 'Claude Lorrain's
"A Wooded Landscape"', *Art Bulletin of Victoria* 28, pp. 55-8, fig. 7.

In 1960, an album of some sixty-one drawings by Claude Lorrain was rediscovered.[*] This
find was remarkable not only for the dazzling quality of the works – some Roethlisberger
describes as the finest specimens of their kind – but also for their pristine condition, for
unlike most of Claude's twelve hundred known drawings these had never been exposed to
light, remaining for nearly three centuries within a bound album.[†] It is suggested that the
album was put together by Claude's heirs, but it is only recorded positively for the first
time in the inventory of Livio Odescalchi who died in 1713. The album was taken
apart in 1970 to free the drawings from the damaging effects of glue, though the group
remained virtually intact until 1980 when the sheets were sold individually and dispersed.
Those of the drawings which are dated cover all periods from 1633 to 1677.[‡] *A Wooded
Landscape* was number nine in the original album and is one of only three on prepared pink,
tinted paper which suggests that it was a special undertaking.

This deceptively simple composition carried out almost entirely in wash is a distillation
of his nature drawings which have been transformed into a poetic arcadian vision. The
tranquil mood is unbroken by human activity, the only presence is that of the river god who
reclines amid the foreground vegetation. The composition is dominated by two parallel
planes which repeat light and dark motifs and open up on the right to reveal a mountain
peak and perhaps a distant fortification. Only the river god is drawn in pen and the trees
are lightly indicated in chalk, but the rest is achieved entirely by subtle combinations of
wash on pink, tinted paper and touches of white highlighting. In all, it creates a magical
effect, evoking the atmosphere of endless summer afternoons.

[*] Wildenstein Album.
[†] M. Roethlisberger, 1962.
[‡] The present drawing is not dated but Roethlisberger in his 1971 book reconsiders the date to be the 1650s rather than 1660s.

FRANÇOIS BOUCHER
FRENCH 1703-70

Madame de Pompadour
Pastel over sanguine and light grey-blue washes
Signed and dated l.l.: F. Boucher 1754
37 x 27cm Inv. no. 1482/5
Provenance
The Marquis de Menars and Marigny sale, Paris, 1782, no. 282; Bassan, Joullain, no. 282; Edouard Kahn, Paris; J. H. J. Mellaart & B. Houthakker, Amsterdam; Agnew; H. E. ten Cate; Boerner, Dusseldorf; Everard Studley Millar Bequest, National Gallery of Victoria 1965.
Exhibitions
 Amsterdam,1929 ; Rijksmuseum, Amsterdam, 1934; Museum Willet Holthuysen; Houthakker Gallery, Amsterdam, 1952, no. 6; C. G. Boerner, Dusseldorf, 1964; 'The Great 18th Century Exhibition', National Gallery of Victoria, Melbourne,1983.
Literature
E. & J. de Goncourt, *Madame de Pompadour*, Paris, 1888, p. 428; *Pastel uit drie Eeuwen*, Museum Willet Holthuysen, no. 6; U. Hoff & M. Plant, *Painting Drawing Sculpture*, 1968, p. 80, pl. 81; U. Hoff, *Annual Bulletin of the National Gallery of Victoria*, VIII, 1966-67, pp. 16-25; U. Hoff, *The National Gallery of Victoria*, 1973, ill. p. 95; J. Clark, *The Great 18th Century Exhibition*,Melbourne,1983, p. 143; G. Monnier, *Pastels from 16th to 20th Century*, Geneva,1984, p. 21.

This highly decorative portrait of Madame de Pompadour was commissioned in 1754 by her brother the Marquis de Marigny, who was Director of the King's Buildings. Mme de Pompadour, who had assumed the title of 'Marquise' on her official appointment as 'maîtresse en titre' – mistress to Louis XV, in 1745, had become a leading patron of the arts and numbered Boucher among her protégés. In this allegorical portrait she is depicted in that role, shown surrounded by a garland of flowers which is supported by three putti, while before her lie the attributes of the arts she so passionately supported: painting, drawing, sculpture, architecture, literature and music.

 The vogue for pastel drawing reached its zenith in 18th century France, and though there had been a tradition of pastel portraiture in the previous century, the medium did not come into its own until some twenty or thirty years before this portrait was made. The impetus was no doubt the visit to Paris in 1720 of its greatest exponent, the Venetian, Rosalba Carriera whose portraits were at once innovative, technically brilliant, graceful and seductive, and they instantly caught the sophisticated and the popular imagination. Although Boucher does not emulate Rosalba's sparkling pastel technique, the genre of this allegorical portrait derives in part from her early works. Here, Boucher does not use pastel in a painterly fashion, but in some areas almost as if it were a red chalk drawing with delicate hatching. This drawing with its artifice and elegance characterizes the features of rococo design.

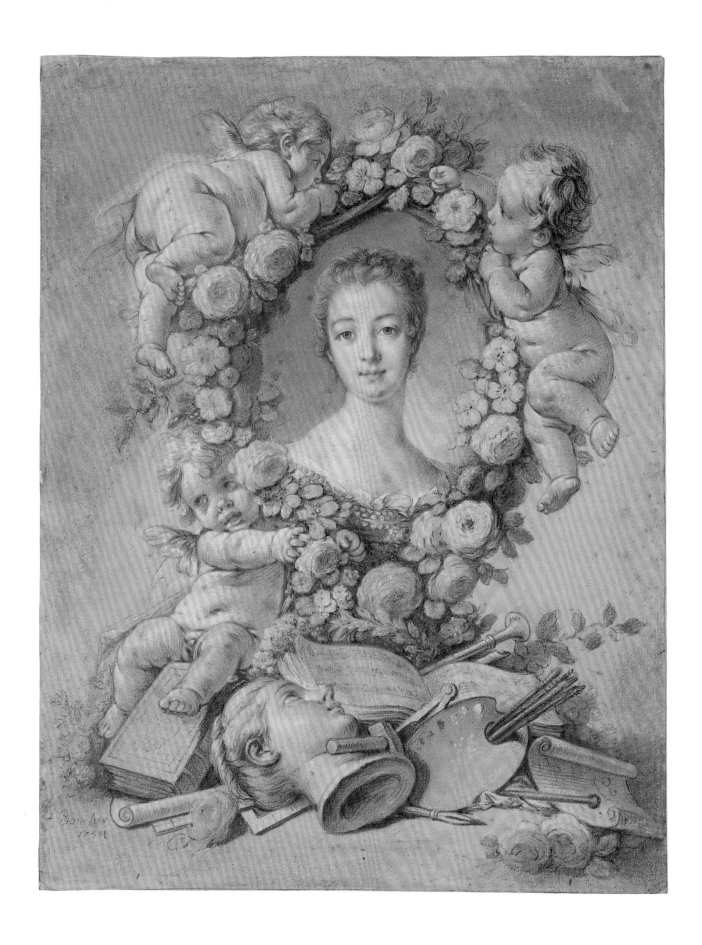

89

FRANÇOIS BOUCHER
French 1703-70

The Adoration of the Shepherds
Brush drawing in monochrome, brown and white pigment over black chalk
Inscribed l.r.: F. Boucher
43.8 x 31.4cm Inv. no. 361/4
Provenance
Boucher sale, February-March 1771, no. 79; Randon de Boisset sale, February-March
1777, no. 189; Henry Oppenheimer; Oppenheimer sale, Christie's, London, 10 July
1936, no. 411; Felton Bequest, National Gallery of Victoria 1936.
Exhibitions
'French Art of the Eighteenth Century', Burlington Fine Arts Club, 1913, no. 28; 'French
Art', Royal Academy, 1932, no. 651; 'The Art of Drawing', 1964-65, no. 9; Hermitage,
Leningrad, 1978-79, no. 20.
Literature
E. & J. de Goncourt, *French 18th Century Painters*, London, 1948; *French Art of the 18th
Century*, London, 1913, no. 28; K. T. Parker, *Henry Oppenheimer Collection*, 1936, no. 411; U.
Hoff, *Annual Bulletin of the National Gallery of Victoria* VIII, 1966-67, pp. 15-25; U. Hoff &
M. Plant, *Painting Drawing Sculpture*, 1968, p. 10, fig. 11; A. Annanoff, *Oeuvre dessiné*,
Paris, 1976, no. 687; S. Dean, Leningrad, 1978, p. 18, no. 20.

Towards 1750, Mme de Pompadour commissioned an altarpiece from Boucher for the
chapel of her newly built Château de Bellevue. This nativity scene was exhibited at the
Salon of 1750, and though it survived the destruction of the Château during the revolution,
it later vanished from view and has never been positively traced.* We know the composition
today from the engraving made by Fessard in 1761, called *The Light of the World.* There
were many preparatory studies for this, one of Boucher's comparatively few religious
subjects. The Melbourne drawing, like a famous study once in the de Goncourt collection,
and another now in the Chanler collection, shows the shepherds presenting gifts. If we
accept the Fessard engraving as the final composition, the painting shows a rather austere
nativity scene with a single shepherd whose hands are clasped in adoration. Among the
studies, which are in various media, there are similarities of detail: for instance, the
shepherd in the foreground of the Melbourne drawing appears in the Chanler drawing.
It is clear that for this composition Boucher turned to the Italian baroque for inspiration.
Ursula Hoff has noted its connections with Guido Reni's *Adoration of the Magi* in the
National Gallery, London, and with Correggio's *Notte*, in Dresden, which Boucher
would have known from engravings.† Regina Slatkin notes wider sources, as well as Reni,
Lodovico Carracci, Lanfranco and Cavedone.‡ The Melbourne drawing, like that once
in the de Goncourt collection, is in oil pigment which again refers back to an Italian source,
the 17th century painter Castiglione whom Boucher much admired.§

 This drawing is thought to have remained in Boucher's possession and to have been
listed in his sale.¶ Like the de Goncourt study it has a brio and liveliness which is missing
in the final, rather solemn composition. The brilliant illumination of the scene and the
vivacious handling of the pigment suggests a sepia drawing, but with greater variety and
depth through the dark accents of the oil pigment.

* In 1932, C. Jeanneret claimed that the *Nativity* in Musée des Beauxi-Arts, Lyon, was the lost altarpiece from Château de
Bellevue.
† U. Hoff, op. cit., p. 20.
‡ R. Slatkin, *François Boucher in North American Collections*, National Gallery of Art, Washington, 1974.
§ U. Hoff notes that Boucher submitted a work to the Salon in 1769 'painted in the style of Bendetto'; U. Hoff, loc. cit.
¶ A. Annanoff, loc. cit.

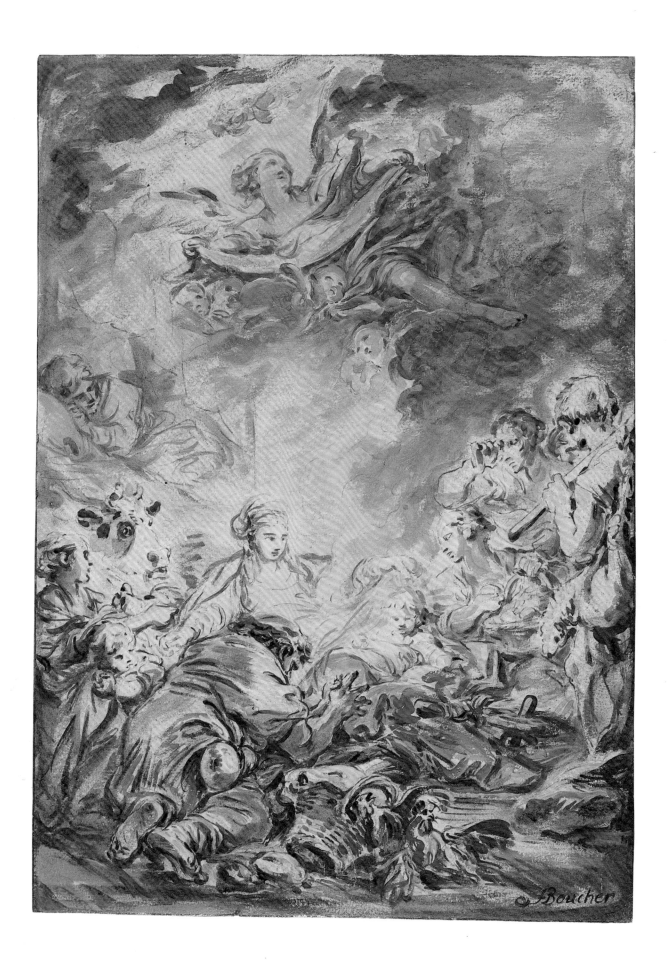

JEAN HONORE FRAGONARD
French 1732-1806

Ruggiero is assailed by a Groom, a Horse, a Bird and a Dog
Illustration for *Orlando Furioso*
Black chalk, grey and brown wash
39 x 25.5 cm Inv. no. P.18/1977
Provenance
One of 137 drawings said to have been acquired from Fragonard's family by Hippolyte
Walfredin; Walfredin sale, 1880; Louis Roederer, Rheims; U.S. private collection; Agnew;
Felton Bequest, National Gallery of Victoria 1977.
Exhibitions
Hermitage, Leningrad, 1978-79, no.32.
Literature
E. Mongan, P. Hofer & J. Seznec, *Fragonard Drawings for Ariosto,* London, 1945, pl.39;
S. Dean, Leningrad, 1978, p.19, no. 32.

Fragonard's series of illustrations for Ariosto's epic poem *Orlando Furioso* seem to
have numbered about 150 of which 137 survive. There is no complete contemporary
documentation for this scheme but scholars have suggested that it dates from the 1780s.[*]
We do not know for whom or for what purpose he made these drawings: presumably they
were to be engraved, but the task was never completed. Of the forty-six cantos which make
up the poem, Fragonard illustrated only about twenty-five and these do not progress in
any regular sequence: some episodes are omitted completely while others have several
illustrations. The text is complex and incident-packed which affords Fragonard's wit and
invention a free reign, though Jean Seznec points out that he always remains true to the
original text.[†] The energy, exhuberance and full-bloodedness of the illustrations – which
have more the character of sketches – is astonishing. They are all executed in chalk, ink
and washes, which vary in colour from brown to grey. The compositions are free,
sometimes verging on the abstract, yet full of precise detail.

This drawing illustrates Canto VIII 8-9 in which Ruggiero fleeing Alcina is waylaid
by a servant who sets his falcon and his dog upon him. Assaulted on three sides, Ruggiero
draws his sword while his harassed steed rears almost in parody of a horse from some
baroque painting.

[*]E. Mongan, P. Hofer & J. Seznec, op.cit., p.22.
[†]ibid.

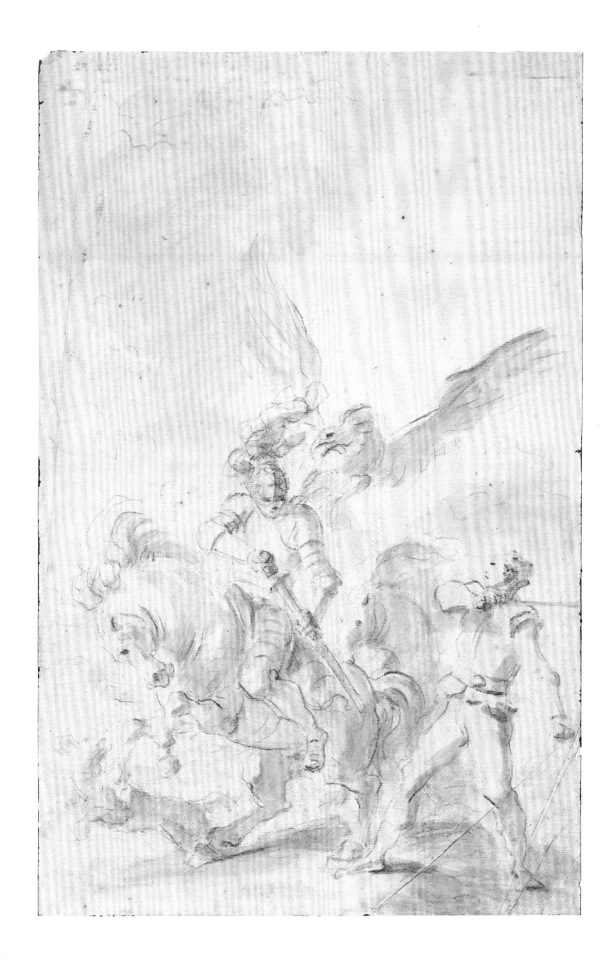

JEAN-ETIENNE LIOTARD
Swiss 1702-89

Lady in Turkish Dress, Reading
Red and black chalk, recto and verso
Watermark:PS
17.6 x 22.8cm Inv. no. 2354/4
Provenance
K. T. Parker, Oxford; Felton Bequest, National Gallery of Victoria 1951.
Exhibitions
'The Great 18th Century Exhibition', National Gallery of Victoria, Melbourne,1983.
Literature
U. Hoff & M. Plant, *Painting Drawing Sculpture*, 1968, p. 80; J. Clark, *The Great 18th Century Exhibition*, Melbourne, 1983, p. 81.

Portraits of Europeans in Turkish costume enjoyed a great vogue in an 18th century society enchanted by the idea of 'turquerie' and exoticism. It was an enthusiasm which invaded every area of taste, fanned by literature like Voltaire's tragedy *Zaire* of 1732, travel books, and by more specific accounts like Guer's *Moeurs et Usages des Turcs* of 1746. When Liotard returned to Europe – a painter who had lived in Constantinople, who affected Turkish dress and beard, had brought back with him genuine Turkish costumes, and had a meticulous drawing technique – he found no want of sitters.

We do not know the identity of the woman who posed for this drawing.* K. T. Parker has pointed out that the pose is inspired not by the east, but by a Boucher drawing, which in turn was engraved for Guer's book of 1746 and was probably seen there by Liotard.†
It seems almost certain therefore, that the drawing can be dated after 1746. The austerity of Liotard's setting appears to have a more authentic air than the sensuous rococo manner of the Boucher-inspired engraving.

Parker cites three versions of this drawing: one in oils, and most notably, one at Carcassonne, which differs from the Melbourne drawing only in the angle of the woman's left arm, which lies in a diagonal.‡ Interestingly,that drawing has a pentimento which suggests that Liotard was already considering the more satisfactory solution of extending her arm along the back of the couch as in the Melbourne drawing, indicating that the latter post-dates it.

Liotard's meticulous miniaturist technique is fully conveyed in this exquisitely executed drawing. In order to enrich the effect, he has drawn on the verso in diagonals of red and black chalk which glow through the almost transparent paper, creating an unexpected luminosity.

*Roethlisberger states that in his opinion it is not possible to identify the sitter (correspondence 1985). The drawing is to be included in Roethlisberger's forthcoming catalogue of the complete works of Liotard.
†K. T. Parker, *Old Master Drawings* V, September 1930.
‡ibid.

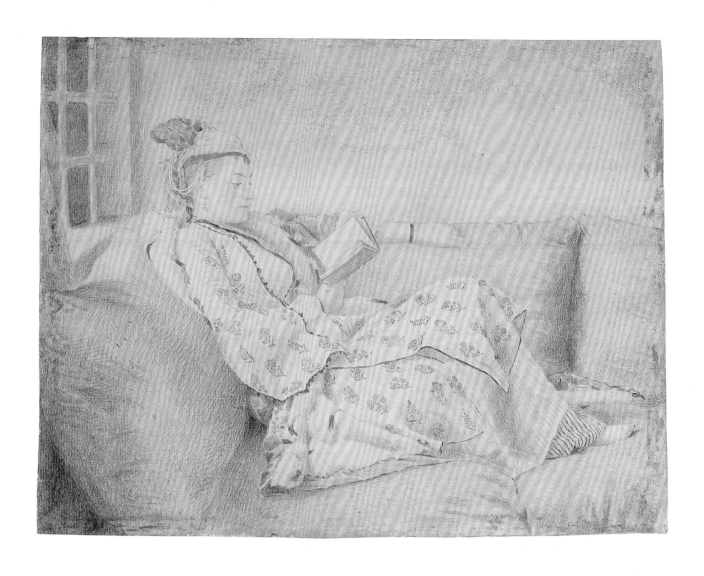

JEAN-AUGUSTE-DOMINIQUE INGRES
French 1780-1867

The Tomb of The Lady Jane Montagu
Graphite with ochre wash, pen and brown ink
Inscribed l.l: J. A. Ingres inv. e del Roma 1816; l.r.: Roma 1815; l.c.: Elle étoit de ce monde
où les plus belles choses/Ont le pire destin;/Et rose, elle a vécu ce que vivent les roses,/
L'espace d'un Matin. Malherbe
44.5 x 55.8cm Inv. no. 1066/3
Provenance
Sold in Rome by Ingres?; Christie's, London, 30 March 1920, no. 122; Felton Bequest,
National Gallery of Victoria 1920.
Exhibitions
'The Age of Neo-Classicism', Victoria & Albert, London, 1972, no. 666; Hermitage,
Leningrad, 1978-79, no. 34; 'French Painting: The Revolutionary Decades 1760-1830',
Art Gallery of New South Wales, Sydney, National Gallery of Victoria, Melbourne,
1980-81, no. 83; 'In Pursuit of Perfection, The Art of J-A-D Ingres', J. B. Speed Art
Museum, Louisville, 1983, no. 36.
Literature
E. Saglio, 'Un nouveau tableau de M. Ingres, liste complete de ses oeuvres', *La
correspondence Litteraire*, 5 February 1857, p. 77; C. Blanc, *Ingres sa vie et ses ouvrages*, Paris,
1870, p. 144; A. P. Oppé, 'Ingres', *Master Drawings*, September 1926, p. 20, pl. 29; Ternois,
*Les Dessins d'Ingres au Musée de Montauban,*Paris,1959, nos 134-7; *The Age of Neo-Classicism*,
London, 1972, pp. 374-5, no. 666; H. Toussaint, *French Painting: The Revolutionary Decades
1760-1830*, Sydney, 1980, p.161, no. 83; S. Dean, Leningrad, 1978, p. 19, no. 34; P. Condon
with M. Cohn & A. Mongan, *Ingres: In Pursuit of Perfection. The Art of J-A-D Ingres*,
Louisville, 1983, p. 100, pl. 187.

Lady Jane Montagu was only twenty when she died in Rome on 27 September 1815. This
exquisite drawing was made by Ingres a year later, but the inscription in the lower right
'Roma 1815' refers back to the sad event. Ingres, while living in Rome had relied on the
commissions of wealthy English and French expatriates and visitors and seems already
to have known Jane Montagu's family. She was the elder daughter of the 5th Duke of
Manchester who was at the time also Governor of Jamaica. It is thought to have been the
girl's aunt, the Dowager Duchess of Bedford, who commissioned the drawing which takes
the form of a design for a projected tomb.* The drawing itself, however, was probably
intended to be the memorial. It is recorded that the pose was one the artist remembered
from life, though significantly it is also a pose familiar from Roman funerary monuments.†
Further suggestion of its funereal intent is seen in the candelabra‡ and confirmed in the
inscription of an elegiac verse by the 16th-17th century French poet Malherbe from the
Consolation à M. du Perrier, here translated:
> She was of this world in which the finest things suffer the worst fate.
> Rose that she was, she lived as roses live: the space of one morning.

The couch is draped with a patterned cover, in its centre the coat-of-arms of the family
of the Duke of Manchester is set above the initial 'M', while the heraldic devices from the
coat-of-arms of three conjoined lozenges and an eagle are repeated in a formal design.

It seems that Ingres regarded this drawing as one of his major undertakings from the
years in Rome, and saw it in a different context from the commissioned portraits of
aristocrats he had made there; for when a selection of his work was being chosen to be
published by Reveil in 1851 he included the project for Jane Montagu's tomb. There is
another version of the drawing in the Montauban museum in a vertical composition,
more elaborately funerary with putti closing the curtains upon the tomb.§

*See A. P. Oppé, op. cit., and subsequent writers.
†M. F. Briquet notes similarity to a motif on a Roman cinerary urn in the Louvre; see *The Age of Neo-Classicism*, op. cit.; Hélène
Toussaint suggests Ingres could have seen an engraving of this or a similar work.
‡H. Toussaint suggests Piranesi's *Vasi Candelabri, cippi* 1778 as a source.
§There are in all, five related drawings and an engraving connected with the enterprise.

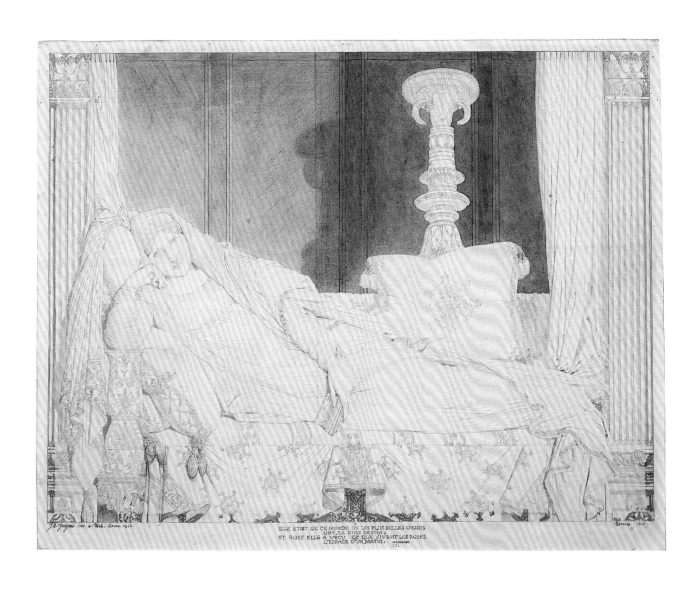

ELLE ETOIT DE CE MONDE OU LES PLUS BELLES CHOSES
ONT LE PIRE DESTIN ;
ET ROSE ELLE A VECU CE QUE VIVENT LES ROSES
L'ESPACE D'UN MATIN.

EUGENE DELACROIX
French 1768-1863

Le Christ au Jardin des Oliviers Christ in the Garden of Olives
Watercolour with traces of pencil
Inscribed l.l.: Eug. Delacroix
21.3 x 28cm Inv. no. 121/1976
Provenance
Dr Baude; Alphonse Royer; M. Charles Narrey; Mme D. David-Weill; Robert Light;
National Gallery of Victoria 1976.
Exhibitions
'Delacroix', Ecole Nationale des Beaux-Arts, Paris, 6 March-15 April 1885, no. 283
[Narrey Collection]; 'Centenaire d'Eugène Delacroix 1798-1863', Louvre, Paris,
May-September 1963, no. 87; Hermitage, Leningrad, 1978-79, no. 23.
Literature
A. Robaut, *L'Oeuvre complet d'Eugène Delacroix*, Paris, 1885, p. 53, no. 177; *Centenaire d'Eugène Delacroix*, Paris, 1963, p.39, no. 87; *Memorial de l'Exposition Eugène Delacroix*, Paris, 1963, p. 59, no. 90; L. Johnson, *The Paintings of Eugène Delacroix, A critical catalogue 1816-1831*, Oxford, 1981, vol. l, p. 167; S.Dean, Leningrad, 1978, p.16, no. 23.

Delacroix, writing in his *Journal* on 12 January 1824, refers to a commission 'for the Prefect' on which he has started work, and there is more specific mention of this painting in journal entries of the 29th of April and the 1st and 3rd of May that year. It is thought that the work in question was *Christ in the Garden of Olives* which had been commissioned for the City of Paris, and that the 'Prefect' was the Count de Chabrol, Prefect of the Seine. The painting, designed to hang in the Church of Saint-Paul-Saint-Louis, was completed in 1827. Delacroix chose to illustrate St Luke's account of 'The agony in the garden' where Christ goes with his disciples to the Mount of Olives, and knowing the destiny he is to fulfil withdraws to pray alone. He specifically illustrates the moment when 'there appeared an angel from heaven to strengthen him' (Luke 22:43) – the only gospel to describe the detail.

The Melbourne watercolour has usually been considered to be a study for this painting though there are substantial differences between the two compositions.*In the painting of 1827, the angels have been transferred from the left of the composition to the right, while Christ facing them raises his left hand in an authoritative gesture of dismissal which suggests his final acceptance of God's will. The vulnerable figure of Christ shown in the watercolour has thus given way to an assertive presence in the Paris painting. Such great contrasts imply a total re-interpretation of the text. Lee Johnson has suggested that the watercolour is not a study for the Paris painting but is a variation on the theme of Christ in the Garden of Olives, a work complete in its own right.† It was made sometime between 1824 and 1827.

* *Memorial de l'Exposition Eugène Delacroix*, loc. cit.
† L. Johnson, loc. cit.

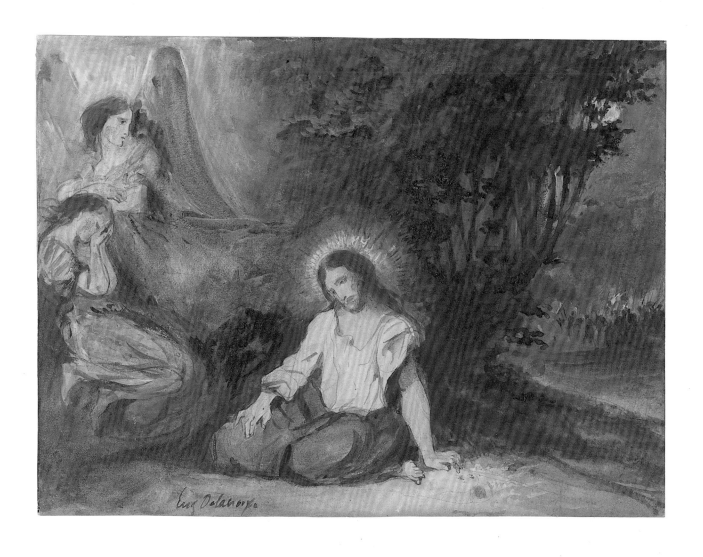

JEAN FRANÇOIS MILLET
French 1814-75

La Becquée The Little Mouthful
Black chalk on oatmeal paper
Millet sale stamp l.r.: J.F.M. [Lugt 1460]
22.8 x 23.8cm Inv. no. 1210/3
Provenance
Millet sale, 1875; Felton Bequest, National Gallery of Victoria 1921.
Exhibitions
'The Art of Drawing', 1964-65, no. 24; Hermitage, Leningrad, 1978-79, no. 27.
Literature
C. Holmes, 'Corot and Millet', *Studio*, 1902; U. Hoff, *The Art of Drawing*, no. 24;
Jean-Francois Millet, Paris, 1975, p. 194, no. 155; U. Hoff, *The National Gallery of Victoria*,
1973, p. 187; S. Dean, Leningrad, 1978, p. 18, no. 27.

Despite the immense popularity Millet eventually enjoyed for paintings like *The Angelus*, he was, and remained, pre-eminently a draughtsman and for most of his life he made a living from his drawings rather than his paintings.

This preliminary sketch for *Feeding the Family*, a painting now in the Musée des Beaux Arts in Lille, has an immediacy and directness which renders it quite free from any hint of sentimentality. In common with most of Millet's drawings made after 1850 the medium is black crayon rather than charcoal, the linearity of the sharp greasy crayon replacing the soft tonal effects of charcoal.

Millet rarely drew from life, preferring to rely on observation and memory. He liked to contemplate a subject over a period of time, refining it to its essentials and stripping away extraneous detail or artifice. In this, his drawings lose none of their immediacy and the honesty of his observation is nowhere more touchingly apparent than in this study of three tiny children waiting like small birds for the food to be put in their mouths.

We know from a letter which Millet wrote to his friend Sensier that he had completed a drawing for this composition by April 1859 and it seems probable that this sketch pre-dates that drawing. The Lille painting was finished the following year. There are four other studies for this composition in the Louvre.

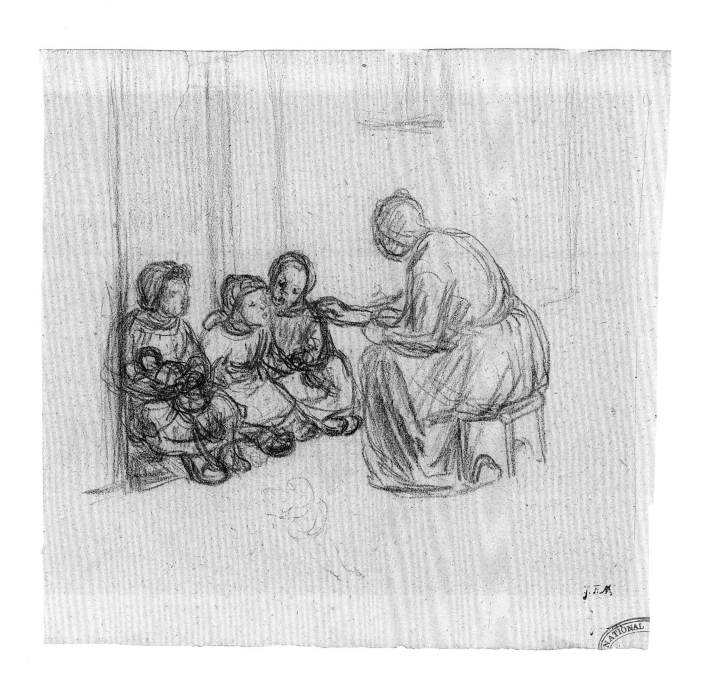

HONORE DAUMIER
French 1808-79

Les Piéces à Conviction Exhibit A
Black and coloured crayon, pen, wash and watercolour, heightened with gouache
Inscribed l.l.: h. Daumier
32.4 x 47cm Inv. no. 1336/3
Provenance
Bellino; C.L. Lawrence; Durand-Ruel; Sir Michael Sadler; Felton Bequest, National Gallery
of Victoria 1924.
Exhibitions
'Exposition de Tableaux, statues et objets d'art au profit de l'oeuvre des orphelins d'Alsace
Lorraine', Louvre, Paris, 1885, no. 102; 'La Caricature', Paris, 1888, no. 393; 'Exposition
Centennale', Paris, 1889, no. 134; 'Daumier', Barbizon House, London, 1923, no. 11;
Tate Gallery, London, 1924, on loan; Tate Gallery, London, 1961, no. 214; Hermitage,
Leningrad, 1978-79, no. 25.
Literature
A. Bellino, *Catalogue de la Vente*, Paris, 1892, no. 31; *Catalogue of the Cyrus L. Lawrence Sale*,
New York, 1910, no. 32; *Art Journal*, 1911, pp. 313, 323; E. Klossowski, *Honoré Daumier*,
Munich, 1923, 134B; R. Escholier, *Daumier, Peintre et Lithographe*, Paris, 1923, p. 159;
R. Escholier, *Daumier*, Paris, 1930, pl.81; R. Escholier, *Daumier*, Paris, 1938, p. 75;
M. Sadleir, *Daumier: The Man and the Artist*, London, 1924, pl.37; E. Fuchs, *Der Maler
Daumier*, Munich, 1927, 192b; Fleischmann & Sachs, *Honoré Daumier*, Paris, 1939, pl.29;
J. Lassaigne, *Daumier*, London, 1938, pl.86; C. Schweicher, *Daumier*, London, 1954, pl.31;
N. Kalitina, *Honoré Daumier*, Moscow, 1955, pl.55; J. le Foyer, *Daumier au Palais de Justice*,
Paris, 1958, pl.54; K. E. Maison, *Honoré Daumier*, London, 1962, vol. II, no. 642; S. Dean,
Leningrad, 1978, p. 17, no. 25.

Daumier's sardonic view of the workings of the law and of the Palais de Justice are seen in
his lithographic series of the 1840s and 1860s, but he frequently returned to this subject in
some of his single sheets – drawings made entirely for their own sake not for lithographs,
like this elaborately finished watercolour. His satirical drawings are never anecdotal, but
rather fix upon a moment summarized perhaps in an expression which can be universally
recognized, an eternal truth. The three judges in this drawing are seen to be complacent,
supercilious and bored as they sit before the prosecuting evidence – a blood-stained shirt
and a knife – while behind them we see the lower part of a painting of the Crucifixion
which hangs in the Salle du Tribunal. Daumier sets up an ironic counterpoint between the
three elements – judges, the symbol of mercy and court evidence – but the key to the
situation lies in the judges' facial expressions, and the implications are masterly.

Daumier never drew directly from life, rather his subjects are a synthesis of his
observations, archetypal figures whom we all recognize. There is a preliminary drawing in
the Art Institute of Chicago for this watercolour in which composition and attitudes have
been resolved but the expressions have yet to be refined – they still look like individuals –
so that it lacks the bite of the final work. Daumier did not date his work and Kenneth
Maison speculates that this watercolour drawing comes from 1858-60.* It is highly finished
and signed in full, which suggests that Daumier intended it for sale.

*K. E. Maison, op. cit., p. 10.

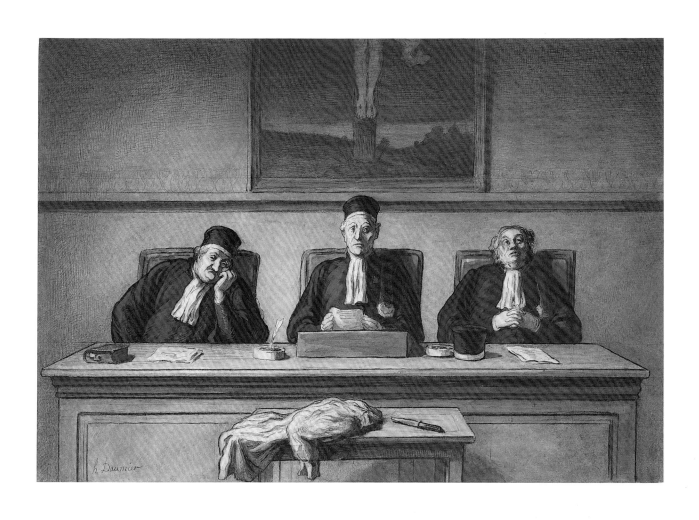

HONORE DAUMIER
French 1808-79

Mon cher Confrère [Mon cher collègue... Avocats] My dear colleague-The Lawyers
Crayon, pen and wash, watercolour and gouache
Inscribed l.l.: h. Daumier
28.6 x 22.3 cm Inv. no. 1235/3
Provenance
C. L. Lawrence; Durand-Ruel; Felton Bequest, National Gallery of Victoria 1922.
Exhibitions
Barbizon House, 1923; Tate Gallery, London, 1961, no. 210; Hermitage, Leningrad,
1978-79, no. 24.
Literature
Catalogue of the Cyrus L. Lawrence Sale, New York, 1910, no. 30; E. Klossowski, *Honoré
Daumier,* Munich, 1923, 177K; M. Sadleir, *Daumier: The Man and the Artist,* London, 1924,
pl.44; E. Fuchs, *Der Maler Daumier,* Munich, 1927, 206b; J. Lassaigne, *Daumier,* London,1938,
pl. 77; J. Cassou, *Daumier,* Lausanne, 1949, pl.14; M. Gobin, *Daumier Sculpteur,* Geneva,
1952, p. 258; K. E. Maison, *Burlington Magazine,* March 1954, p. 85, fig. 25; K. E. Maison,
Honoré Daumier, London, 1962, no. 600; U. Hoff, *National Gallery of Victoria,* 1973, p. 100;
S. Dean, Leningrad, 1978, p. 17, no. 24.

In the series of lithographs of 1845-48 called *Officers of the Law,* Daumier seems to reserve
considerable venom for his depiction of lawyers whom he sees as arrogant, hypocritical and
unsympathetic, both in their theatrical court-room performances and even as they sweep
along the corridors of the Palais de Justice. His view is equally unrelenting in this drawing
of the 1850s in which two lawyers greet one another with an oily courtesy which masks their
personal and professional antipathy. Daumier himself had been victim of the law when he
was imprisoned for his caricature of Louis Philippe as Gargantua, and had had minor
skirmishes with creditors, but this alone does not explain his unremitting view. Rather it
seems that he unerringly spots the flaws and foibles of any group on whom he fixes his eye.
Like *Les Piéces à conviction,* this is a watercolour drawing which has been worked up to a
high finish, presumably for sale: Kenneth Maison suggests that it dates from 1855.

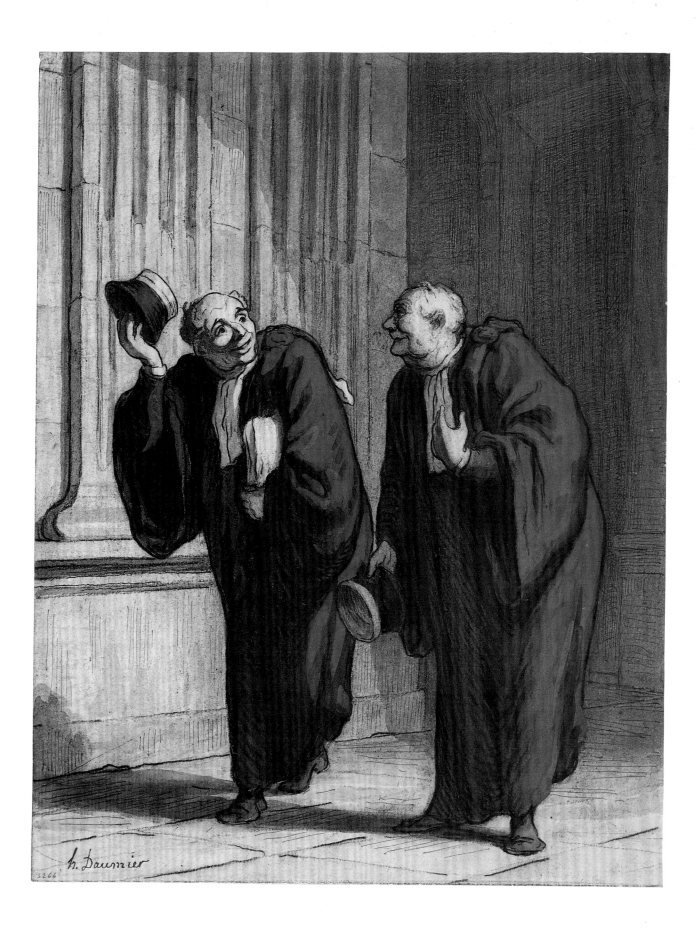

CAMILLE PISSARRO
French 1830-1903

Le Marché à la Volaille, Gisors
Study for *The Poultry Market at Gisors*
Black chalk and pastel
31 x 23.5 cm Inv. no. P.22/1983
Provenance
The artist, by descent to Paul-emile Pissarro 1956; purchased through The Art Foundation
of Victoria with the assistance of Mr & Mrs William Jamieson, Members, for The National
Gallery of Victoria 1983.
Exhibitions
'Camille Pissarro 1830-1903', Tolarno Galleries, Melbourne, July 1983.
Literature
Camille Pissarro 1830-1903, Melbourne, 1983; C. Lloyd, 'A New Drawing by
Camille Pissarro', *Art Bulletin of Victoria* 25, 1984, pp. 17-32, fig. 1.

Camille Pissarro and Edgar Degas were prolific draughtsmen who each used drawing in
a very traditional way in relation to their paintings. Christopher Lloyd has pointed out that
the apparent spontaneity of impressionist paintings often belies the underlying preparation
and the many preliminary drawings which lead up to the final composition.* Although
Pissarro would record many sketches from life, when a composition was resolved he would
frequently make some of the final drawings from a posed model in his studio.

Predominantly a landscape painter, figures played a secondary role in his work until the
early 1880s when they began to assume a more dominant place in the composition. As this
interest in figure compositions increased, he turned for inspiration to the vegetable and
poultry markets of local French provincial towns like Pontoise and Gisors which provided
an endless flow of subjects for drawings, paintings and prints.

This drawing of a market woman bending over her basket relates to one of these
compositions – *The Poultry Market at Gisors* – dated 1885, a tempera painting which once
belonged to Claude Monet and is now in the Museum of Fine Arts, Boston. The figure
seen in the Melbourne drawing appears in the foreground of the painting in an almost
identical posture. There is another chalk study for this same figure in a private collection
which shows not a single figure but a group of people including a seated woman who also
appears in the foreground of the painting.†

The Melbourne study seems almost certainly to have been drawn from a posed model,
consistent with Pissarro's working methods. It is a clear, concise statement with all decisions
now fully resolved. The bold confident contours are drawn in black chalk, while pastel
plays very much a secondary role.

*C. Lloyd, *Pissarro*, Hayward Gallery, London, 1980, p. 157.
†C. Lloyd, 1984, fig. 5.

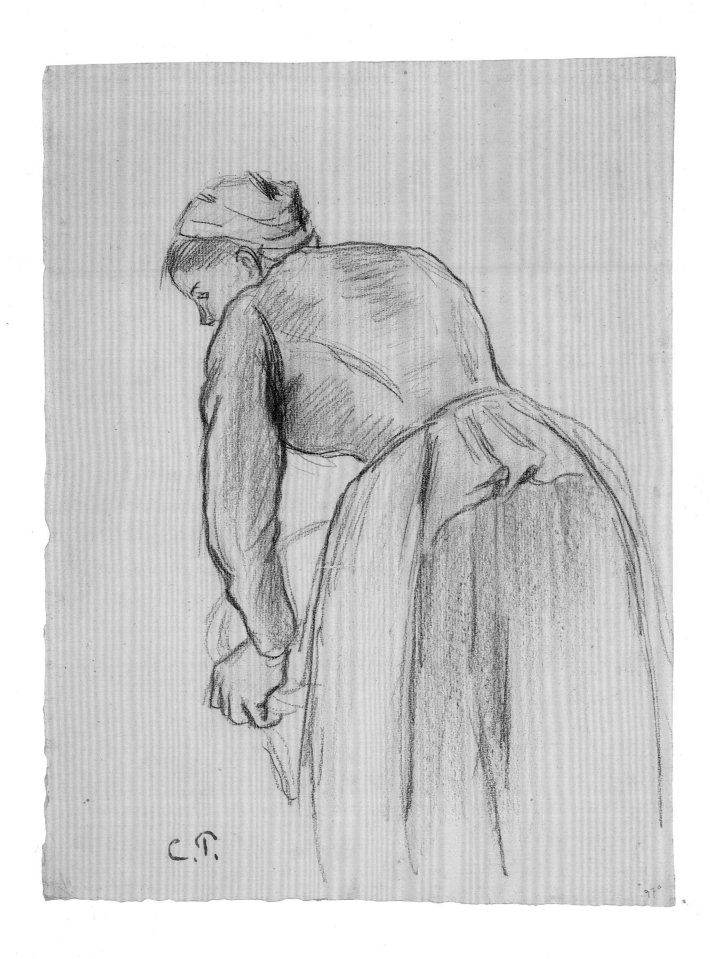

AUGUSTE RODIN
French 1840-1917

Nue avec draperie Nude with Drapery
Pencil and watercolour on smooth wove cream paper
Inscribed u.l.: .../Nous/vivons sous/un mur de/nuees cet arche/de noe aero/la seine
colosse en hauteur/proue/de/navire
50.3 x 32.3 cm Inv. no. 6/1971
Provenance
Jacques Zoubaloff; Galerie Georges Petit, 16-17 June 1927, no. 103; Mme J. Danthon;
Hôtel Drouot, 24 May 1933, no. 12; Gaby Salomon, Buenos Airès; Sotheby's, London,
11 December 1969, no. 5 [by Arthur Tooth for Salomon]; Leslie Waddington; National
Gallery of Victoria 1971.
Literature
Galerie Georges Petit, 1927, no. 103; *Hôtel Drouot*, 1933, no. 12.

The discipline of drawing was central to Rodin's understanding of human form; through it
he explored the different facets of the human body in movement and repose. The drawings
– from the last twenty-five years of his life – are seldom if ever studies for actual sculptures,
but rather explorations which inform all his other works. There are numerous contemporary
accounts of how Rodin set about making these drawings.* The model was placed in a pose
which could be held only fleetingly – 'an essentially unstable pose' Clement Janin called it,
from which Rodin would make a series of rapid pencil drawings, looking all the time at the
model and never referring back to the paper to make any corrections. In these fluent
drawings he was able to grasp and record without reflection or pause, the essentials of
a movement.

He would then sometimes take a second sheet of paper and trace over the first drawing,
simplifying or strengthening it. Next he might add watercolour and finally rework the
drawing very freely and vigorously in heavy pencil, jotting down fragmentary prose in
the margin of the paper which reflects the same free flow of ideas as the drawing. These
processes might follow rapidly on one another or take years, for Rodin kept his drawings
and constantly referred back to them, reworking them as he felt inspired.

In this study, his model has been posed in the manner of an antique sculpture, perhaps
Venus Genitrix, the Venus of Arles or the Venus Callapyge, all of which were well known
to the artist. The languid gesture of the initial life drawing is transformed in the energetic
reworking and has become more ecstatic, athletic and abandoned. She now stands on the
prow of a boat, a dolphin at her feet. There is a further clue, though an elusive one, in the
partly decipherable words jotted down to the right of the sheet. They appear almost
random, written in a stream of consciousness, as the ever-changing visual image evokes
a series of literary associations.

The drawing appeared under the title 'Etude pour L'arche de Noe' in the Georges Petit
sale in 1927, probably due to the inscription and not necessarily because it was Rodin's
intended title. No closely related sculpture has been found but there is a clearly related
drawing in the Stieglitz collection, Chicago, dated 1904-05, which Kirk Varnedoe suggests
could have come from the same initial drawing session as the Melbourne version.†

*C. Janin, *Les Dessins de Rodin*, 1903.
†K. T. Varnedoe in correspondence to S. Dean 1971.

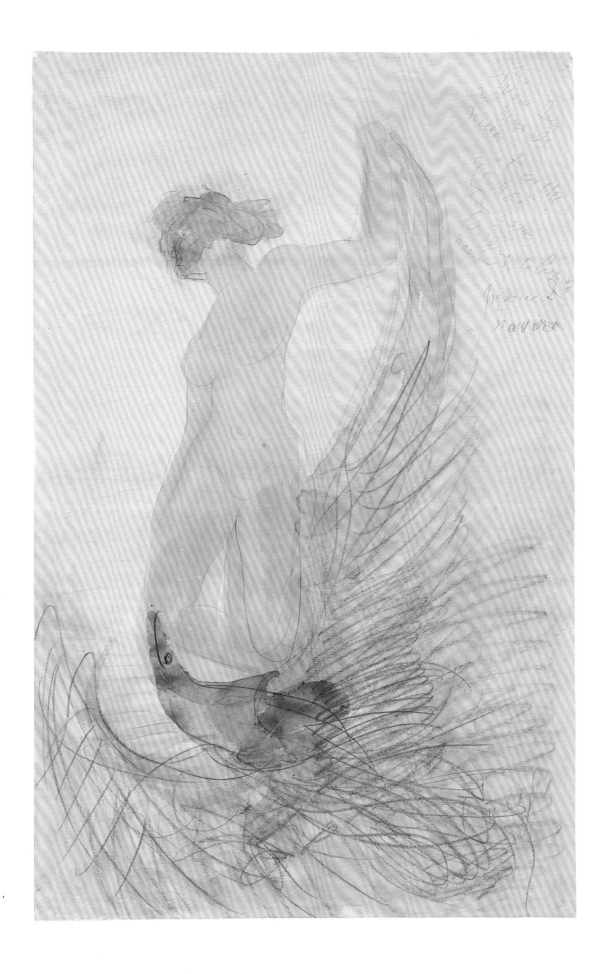

HILAIRE-GERMAIN-EDGAR DEGAS
French 1834-1917

Femme s'essuyant Woman drying herself
Charcoal
La vente de l'atelier stamp in red [Lugt 658] l.l.
73.3 x 70.6cm Inv. no.1801/4
Provenance
In the artist's studio at his death, his atelier sale, Zwemmer Gallery, Felton Bequest,
National Gallery of Victoria 1947.

This drawing dating from 1890-95 is a study for a composition called *Baigneuses,* which
shows three women: one combing her hair, another reclining and a third drying herself
with a towel.* There are a number of single studies for the three women; most closely
related to the Melbourne drawing is a pastel which is more highly finished than this
charcoal study.†

In the last impressionist exhibition of 1886, Degas had exhibited seven pastels depicting
nudes: women washing, bathing or drying themselves, and combing their hair. Public and
critical reaction to these works was mixed, the power of the drawing was admired but the
depictions were seen as brutal and malicious. The women are shown entirely absorbed in
their own activities and oblivious of the spectator. Degas explained to George Moore that
he intended the models to look as if they were being observed through a keyhole.‡

In this study, Degas is interested not in the individual but in the contained energy of the
figure and the impetus of its forward movement. Degas's maxim that drawing is a way of
seeing form is expressed in the rigorous simplicity of the contours: details of hands, feet
and face are irrelevant.

Frequently, in his late drawings, Degas used tracing paper and charcoal. He sometimes
traced from another study, simplifying and reinforcing the solidity and vigour of the form.
He would make numerous studies based on a single pose, experimenting and honing down
the image, exploring the full potential of each posture. Degas kept many of the studies in
his studio for reference and the red 'Degas' mark in the lower left of this drawing shows
that it passed through one of the sales of works from the artist's studio in 1918 or 1919.

* P. A. Lemoisne, *Degas et son Oeuvre*, Paris, 1946, no. 1071.
† ibid., no. 1074.
‡ G. Moore, *Impressions and Opinions*, New York, 1891.

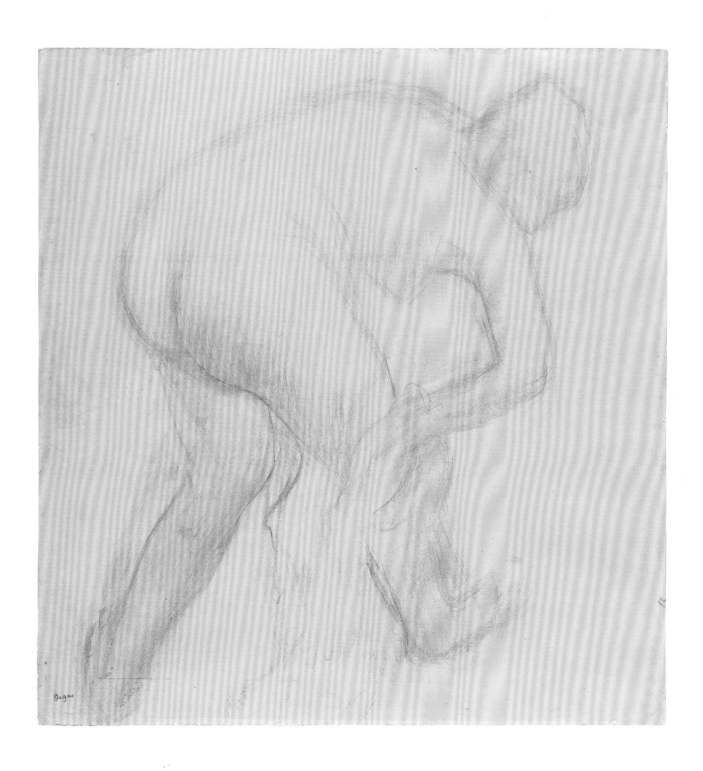

PABLO RUIZ PICASSO
Spanish 1881-1973

Woman with a Fan
Pen and black ink
Signed in pencil l.r.: Picasso
32 x 24.8 cm Inv. no. 1794/5
Provenance
Leo Bollag, Zurich; Wurmser, Zurich; Galerie Obere Zaune, Zurich; Roland, Browse and
Delbanco, London; Felton Bequest, National Gallery of Victoria 1967.
Exhibitions
'Drawings of Importance from 1860-1960', Roland Browse and Delbanco, May-June 1967,
no. 8; Hermitage, Leningrad, 1978-79, no. 28; 'Picasso' National Gallery of Victoria, Melbourne,
Art Gallery of New South Wales, Sydney, 1984, no. 21.
Literature
P. Daix & G. Boudaille, *Picasso, the Blue and Rose Periods, a Catalogue Raisonné, 1900-1906*,
English edn , London, 1967, p. 251, no. D.XI.23; U. Hoff & M. Plant, *Painting Drawing and
Sculpture*, 1968, p. 14, fig. 13; U. Hoff, *The National Gallery of Victoria*, 1973, p. 102; S. Dean,
Leningrad, 1978, p. 18, no. 28; I. Zdanowicz, 'Woman with a Fan', *Gallery: Bulletin of the
National Gallery Society of Victoria*, September 1984; *Picasso*, Sydney, 1984, no. 21.

Picasso returned to Paris from Barcelona in the spring of 1904. It was a transitional phase
in his art, signalling the end of the sombre, introverted subjects of the blue period and the
beginning of the new, more optimistic, rose period. This drawing made that year is a direct
life drawing which shows a young girl posed in her street clothes – a high-necked dress and
tall feathered hat. She sits rather self-consciously with her long hands folded, holding in
one a closed fan. The mood is contained, even withdrawn.

The drawing was perhaps made with no thought of a painting, and only in retrospect can
it be seen as the initial idea for the painting of 1905, *Woman with a Fan*, which is now in the
National Gallery of Art, Washington. The idea was to gestate for a year, though early in 1905
there was another drawing in which we see a girl posed identically, except that she has removed
her hat, and the high-necked dress is replaced by some less specific tunic.* The face too is
more generalized and the expression brooding in contrast to the alert pointed features of
the sitter in the Melbourne drawing. In mood it is closer to the Washington painting, but
both are derived unmistakably from the 1904 study.

A feature already apparent even in the earlier drawing, with its essential linearity and
narrow profile view, and still more marked in the hieratic pose of the figure in the oil
painting, is the influence of ancient art – no longer just the classical tradition of Greece and
Rome, but of Egypt and Assyria. From Picasso's friend, and later secretary, the poet Jaime
Sabartès, we know that during this period Picasso spent much of his time visiting the
Egyptian and Assyrian halls of the Louvre.† This drawing therefore comes at an interesting
transitional point, predicting both his move towards classical and ancient sources, while
still reflecting his attachment to the French 19th century tradition.‡

Woman with Fan, pen drawing, 1905, Allen Memorial Art Museum, Oberlin College.
†J. Sabartès, *Picasso, Documets iconographiques*, Geneva, 1954.
‡N. Broude has discussed the role of Degas in relation to the Oberlin drawing; *Allen Memorial Art Museum Bulletin* XXIX, 2, 1972.

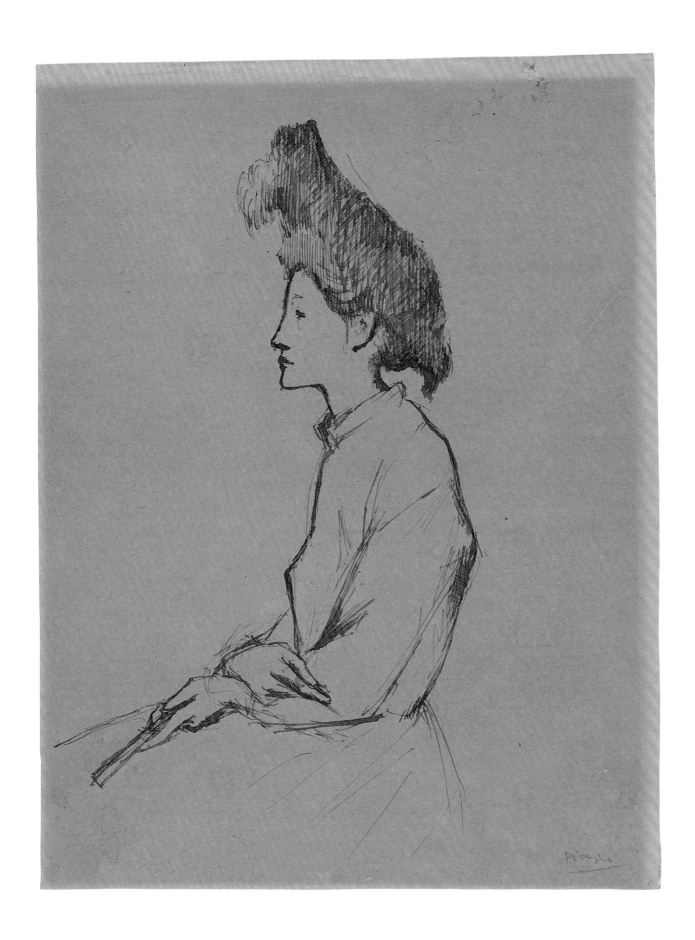

113

PABLO RUIZ PICASSO
Spanish 1881-1973

La Pose du Modèle The Pose of the Model
Illustration to Balzac's *Le Chef d'Oeuvre Inconnu*
Pen and indian ink
Inscribed l.r.: Picasso/26
29.1 x 37.8 cm Inv. no. 1852/4
Provenance
Felton Bequest, National Gallery of Victoria 1948.
Exhibitions
U. Hoff, 'The Art of Drawing', 1964, no. 12; Hermitage, Leningrad, no. 29; 'Picasso', National Gallery of Victoria, Melbourne, Art Gallery of New South Wales, Sydney, 1984, no. 85.
Literature
C. Zervos, *Pablo Picasso, Oeuvres de 1926 à 1932*, Paris, 1955, vol. VII, no. 44; U. Hoff, *The Art of Drawing*, 1964, no. 12, *Quarterly Bulletin of the National Gallery of Victoria* III, 2, 1948, p. 5; S. Dean, Leningrad, 1978, p. 18, no. 29; *Picasso*, Sydney, 1984, no. 85.

In 1926, Ambroise Vollard commissioned Picasso to illustrate Honoré de Balzac's *Le Chef d'Oeuvre Inconnu* – The Unknown Masterpiece.* Balzac's novel is a fable about an elderly 17th century artist, Frenhofer, who has attempted to encapsulate the essence of female beauty in a painting on which he has worked for ten years. When it is finally unveiled, his uncomprehending friends see 'nothing there but colours piled upon one another in confusion...': he had produced a work which had no meaning to anyone but himself. The underlying theme of the novel is the nature of art and the artist's condition and Picasso proved to be an inspired choice of illustrator. The issue of artist as creator, and the confrontation between artist and model and muse are for him central concerns, themes to which he returns in graphic works of the 30s.

Picasso's 1917 visit to Italy marked a return to classical forms which continued in these graphic works. His illustrations for the Balzac – the first narrative series he had tackled – are classical line drawings, executed in a rapid calligraphic manner which invests them with spriteliness and wit. In this drawing, the artist is represented as an antique figure in a tunic, the model in costume sits with a somewhat anticipatory air. The image the artist paints is a naturalistic interpretation of the model though in some of the later etchings for the series he is depicted drawing an abstract image on his canvas.

Vollard published *Le Chef d'Oeuvre Inconnu* in 1931 in two editions: for the book edition there were thirteen etchings and sixty-seven drawings, the latter appearing as wood engravings, by Aubert, while the portfolio edition contained only the thirteen etchings.

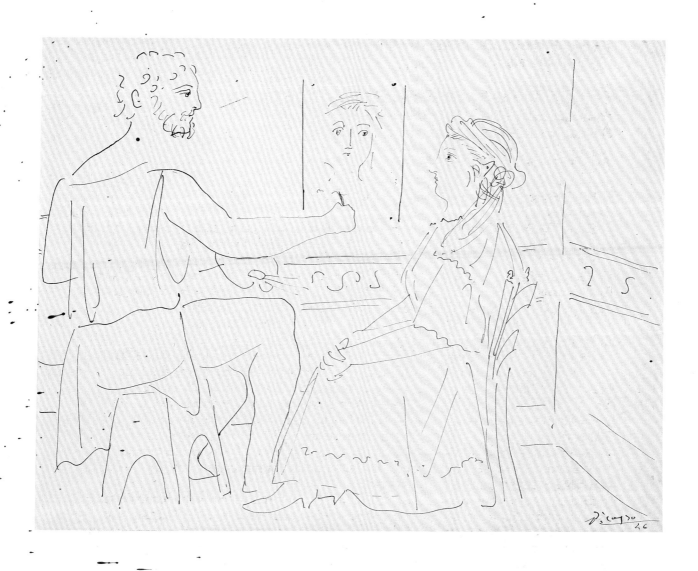